IMAGES
of America

CLEVELAND'S LIGHTHOUSES

IMAGES
of America

CLEVELAND'S LIGHTHOUSES

Janice B. Patterson

ARCADIA
PUBLISHING

Published by Arcadia Publishing
Charleston SC, Chicago IL, Portsmouth NH, San Francisco CA

Printed in the United States of America

Library of Congress Catalog Card Number: 2008936158

For all general information contact Arcadia Publishing at:
Telephone 843-853-2070
Fax 843-853-0044
E-mail sales@arcadiapublishing.com
For customer service and orders:
Toll-Free 1-888-313-2665

Visit us on the Internet at www.arcadiapublishing.com

For Lew and Elizabeth

CONTENTS

ACKNOWLEDGMENTS

Growing up in Kansas does not prepare someone to write about lighthouses. However, living in New England introduced me to real lighthouses and prompted me to visit many more across America. Eventually I began to focus my sights on Cleveland's harbor sentinels. My findings are collected here.

Many people helped make this book a reality. Some were nearby, doing their jobs in libraries, archives, museums, and associations. Others wrote their pieces years ago. Still others are total strangers who eagerly shared their information about lighthouses.

I am especially grateful for the help provided by the following: Rosemary at Cleveland Public Library; John Vacha, Western Reserve Historical Society; Christopher Gillcrist, Great Lakes Historical Society; Michael J. Brodhead, historian, Army Corps of Engineers, Washington, D.C.; Christopher Havern, U.S. Coast Guard Historian's Office, Washington, D.C.; Karen Needles, Documents on Wheels; Lynn Duchez Boyko and William Barrow, Special Collections, Cleveland State University; Doug Sharp, U.S. Coast Guard, Ninth District, Cleveland; Terry Pepper, Great Lakes Lighthouse Keepers Association; and friends Mary Keller, Don Iannone, and Anne Sterling, who added their special expertise here and there. Melissa Basilone at Arcadia Publishing has been ever ready to answer my questions.

Finally, there is no way I could have accomplished this without the support of family and friends who have been extra helpful throughout. At the top of the list is Lew, who climbed more than a few lighthouse towers with me, helped locate information in libraries, and kept the home fires burning as I wandered through this project.

Unless otherwise noted, the images in this book are from the following organizations: Bowling Green State University, Bowling Green (BGSU); U.S. Coast Guard Historian's Office, Washington, D.C. (CGHO); Special Collections, Cleveland State University, Cleveland (CSU); Photographic Collection, Cleveland Public Library, Cleveland (CPL); Clarence Metcalf Library, Great Lakes Historical Society, Vermilion (GLHS); and National Archives and Records Administration, Washington, D.C., and College Park, Maryland (NARA).

INTRODUCTION

Since the sperm oil lamps of the first lighthouse spread a broad beam into the lake in 1830, many kinds of lights, beacons, and buoy markers have guided Lake Erie ships into and out of the harbor at Cleveland. The harbor itself has undergone significant changes to reduce sandbars and silting, to increase its depth, and to straighten the access to the crooked Cuyahoga River. Cleveland's role as a port has grown dramatically. Watching, somewhat invisibly, for 98 of those years have been not one but two lighthouses.

Overlooked by many Clevelanders without a boat or binoculars or a marine-based job, the lighthouses are now an endangered species and may not be part of the lake vistas of the future. For that reason, capturing their memory is important. These sometimes-silent sentinels are presented in depth in the chapters that follow.

In 1831, approximately 425 sailing vessels a year reached the little port of Cleveland on Lake Erie. By 1870, Cleveland had become the largest shipbuilding center in the United States.

Although ships are no longer built in Cleveland, the harbor has been a major regional maritime player through wars, depressions, recessions, bad weather and good. Cleveland is now a world market, handling nearly 1,000 vessels a year that carry over 13 million tons of cargo. Three U.S. flag carriers were operating 19 ships from Cleveland in 2007, 30 percent of the American Great Lakes fleet.

Maritime commerce on the Great Lakes began in the late 1600s when French missionaries, fur traders, and explorers first dipped their oars in the continent's largest concentration of freshwater. Other adventurers traveled the interior rivers of the Northwest Territory and used long-standing Native American paths to discover that several rivers (the Maumee, the Grand, the Chagrin, and the Cuyahoga) terminated at a vast lake. Defensive forts were established where land met the inland seas, bringing soldiers, businessmen, and families to the edge of Lake Erie and creating the need for transport of supplies of all kinds.

In 1796, Moses Cleaveland, lead surveyor of the Connecticut Land Company, reported that the Cuyahoga River "was navigable for lake sloops for five miles and for smaller vessels ten miles farther if the lake was cleared of debris." (Cleaveland was honored by his team by naming the place he founded after him, but early maps omitted the *a*.)

Although the British dominated the lake trade from 1763 until 1813, Americans launched their first lake schooner, the *Washington*, in 1797 on Lake Erie near Presque Isle, Pennsylvania, and many entrepreneurs began chancy trips between lake ports, landing at waterfronts churning with activity. The federal government named Cleveland an official port of entry in 1805 and appointed a customs collector to monitor trade from Canada as well as lake and river traffic. In 1807, a lottery raised $12,000 to make the first expenditures on the Cuyahoga River channel. Six

years later, Adm. Oliver Hazard Perry's victory against the British (September 10, 1813) cleared the United States' rights to Lake Erie.

In 1818, 21 boats entered or cleared the port of Cleveland for Buffalo and Detroit, carrying household goods, stoneware, dry goods, whiskey, livestock, pork, flour, butter, grindstones, and tallow. In 1818, the first American steam-powered ship on Lake Erie, *Walk-in-the-Water*, was launched, and in that same year, the first two American lighthouses on Lake Erie were completed at Erie, Pennsylvania, and Buffalo, New York. The federal government approved lighthouses for the harbors along Lake Erie in rapid succession—Marblehead Lighthouse on Sandusky Bay in 1822, Fairport on the Grand River in 1825, and on a bluff above the Cuyahoga River at Cleveland in 1830. (Conneaut and Ashtabula—active entry points for many settlers of the Western Reserve portion of Ohio—received lighthouses in 1835 and 1836, respectively.)

Through the 1820s, shipbuilding firms and warehouse companies sprung up at water's edge in Cleveland to take advantage of the extraordinary expansion of lake commerce brought on by the completion of the Erie Canal in October 1825, and the canal to the Ohio River a few years later. The water route across the state of New York linked the Atlantic Ocean and Lake Erie, opening a vast agricultural hinterland and making Cleveland a key gateway of distribution.

Establishing a shipping port at Cleveland was not easy. The crooked course of the Cuyahoga River and the nature of the glacier-scraped soil at its mouth made silting an ever-present problem. The first pier, built east of the river in 1827 with a $5,000 appropriation from the federal government, failed to create the needed open channel. A second pier was built to the east of the first, and the channel was changed to flow between the two. Dredging provided 10 feet of water in the channel, and the harbor was deemed a success, although much of the burden of upkeep and improvement had to be supported by private funds. Requests for additional funds to improve the entry point have been perennial issues for Cleveland, the State of Ohio, the federal government, and the shipping industry. The harbor still needs dredging on a regular basis; its breakwaters and piers suffer the constant attack of splashing water and fierce storms.

The federal government's management of all U.S. lighthouses began in 1789 as a responsibility of the U.S. Department of the Treasury, which was already administering the U.S. Revenue Cutter Service. In 1852, a new administrative system was formed, the U.S. Light-House Board. In 1910, Congress abolished this board and created the Bureau of Lighthouses under the Department of Commerce. The lighthouse service was incorporated into the Coast Guard in 1939.

Cleveland's first lighthouse was constructed in 1830–1831 at the southwest corner of Water Street (now West Sixth Street) and Lighthouse Street (now Main or Lakeside Avenue), on a bluff overlooking the harbor. The conical stone structure and associated buildings cost $8,000. Its builder, Capt. Levi Johnson, was prominent in Great Lakes maritime history as both a shipbuilder and a lighthouse builder. This lighthouse, together with a changing variety of pier lights, served Cleveland's shipping interests for more than 40 years.

The 1830 lighthouse was replaced in 1871–1872 by an architectural wonder of brick and stone, built on the same government lot. The two-story attached keepers' quarters continued to serve as employee housing until 1927, long after the tower had been decommissioned and removed.

In the 1880s, nearly five miles of breakwaters were built offshore to provide greater protection for ship arrivals and departures and calmer waters at the expanding docks. This highly political effort involving many dollars, many years, and many strategies also prompted a decision to install a lighthouse on the east end of the West Breakwater in 1885, just 13 years after the tall lighthouse on the hill was first lit.

This hulking brown lighthouse has been largely overlooked or misconstrued in historical accounts although its presence is easily noted in harbor photographs of this era. This lighthouse, moved from Rochester, New York, never adjusted to its Cleveland location despite annual attempts to strengthen its underpinnings. It even needed to be raised 20 feet in 1903 to improve the visibility of its light.

Within the next two decades, the shipping industry moved from wind power to steam power to diesel engines, and ships became longer, wider, and much heavier. The Cleveland harbor

needed further changes to accommodate the marine traffic. Spurs were added to each of the breakwaters to create a calmer entry point to the dock areas. Strong navigational lights were needed too. In 1910–1911, two new cast-iron lighthouses were built on the breakwater pierheads at a cost of $45,000. Both breakwater pierhead lighthouses were still in service in 2008, with their regulation signals operated by solar power.

Writing the biography of a set of lighthouses has had some challenges. Standards for lighthouse literature call for complete descriptions of the towers and of the lighting apparatus, but references for this information about the several Cleveland lighthouses proved to be contradictory. Some differences may be a result of typographical errors that were copied and recopied, but other differences come from variant ways to measure the features. For example, height may be expressed as the number of feet between the ground and the top of the lantern, or the distance from the base of the structure to the center of the lantern, or the distance from water level to the center of the lens (focal plane).

The lenses themselves have details to be recorded. French physicist Augustin Fresnel designed a revolutionary lens in 1822, a prismatic glass structure to be placed in front of a single lamp. He devised seven orders to denote the sizes, and this technical detail is still an important part of lighthouse history. Most Great Lakes lighthouses used the smaller orders. Cleveland's 1872 lighthouse had a three-and-one-half-order lens and was built to take a larger lens if needed. The West Breakwater lighthouse had a new fourth-order lens that was transferred to the West Pierhead lighthouse. The East Pierhead lighthouse had a fifth-order lens. Many manufacturers have made these lenses, but all are typically called "Fresnel lens" in honor of their inventor.

Lighthouse keepers were expected to keep meticulous records, accounting for all supplies and tools used, as well as details on the weather, wind direction, and even sunset and sunrise times, but some keepers wrote very terse reports. The National Archives and Records Administration (NARA) is the repository for such records from every light station in America over the centuries, so the collection is immense. However, many records never made it to the NARA in the first place, and some listed in the catalog cannot be found. (For example, a set of keeper logs labeled "Cleveland" on the outside turned out to contain Huron logs instead.)

Similar problems with the record sets made it hard to identify all the keepers of the Cleveland lighthouses over time. A partial listing has been included at the end of this book. It is interesting to note that only one woman ever received an official appointment as an assistant keeper for the Cleveland lighthouse. She was Antonie Wilhelmy, wife of keeper Ernest Wilhelmy. Antonie's service period was from November 3, 1868, to May 20, 1870, coinciding with most of her husband's term at the Water Street lighthouse, which was January 2, 1867, to May 20, 1870. After her husband died, Antonie lived out her life in Cleveland, residing with her sons until her death in November 1880.

The Cleveland lighthouses, whether on the hill or on the breakwaters, have always had a close relationship with other marine-related entities, especially those concerned with the safety of people and property in and around the harbor. As soon as Cleveland was recognized as a port, the U.S. Revenue Cutter Service came to town, doing its part to contain smuggling and to collect customs duties and tonnage taxes due from ships landing in Cleveland.

In 1876, federal lifeboat stations were established on the Great Lakes and soon Cleveland had a full-fledged lifesaving service with a paid captain and crew. The lighthouse keepers and the lifesaving personnel collaborated from their contiguous harbor vantage points and used their varied expertise to preserve lives and protect property. Many men worked for both government agencies over their lifetimes.

By the end of the 19th century, the waters of Lake Erie were well used by pleasure boaters, bringing new challenges to both the recently created Coast Guard and the U.S. Lighthouse Service. Both agencies were put to a new test between 1920 and 1933, when the manufacture, sale, and transport of alcoholic beverages was prohibited in the United States and rumrunners risked their lives and their boats in efforts to sneak liquor across Lake Erie from Canada. The Coast Guard and the U.S. Lighthouse Service at Cleveland faced fast-changing conditions

during the Spanish-American War and World War I. Shipbuilding companies around Lake Erie worked fast and furiously to build or convert ships for wartime use.

The Coast Guard continued to use the existing lifesaving facilities on the West Pier after 1915 until the 1939 consolidation with the lighthouse service made larger quarters necessary. A striking art moderne–style complex was built on the West Pier and dedicated in 1940, just in time for yet another massive military buildup as the nation went into World War II.

Operations were managed from this site until 1974 when the U.S. Coast Guard's Ninth District headquarters moved to the foot of East Ninth Street next to dockage space that had been used for large vessels for many years. Today the rear admiral commanding this district directs more than 7,000 Coast Guard personnel throughout the eight Great Lakes states, the St. Lawrence Seaway, and parts of surrounding states.

Reuse of the West Pier facility was hampered by its minimal sanitation facilities, and it was allowed to deteriorate. Numerous plans for its redevelopment have been made and scrapped in the past 34 years. In 2007, several Cleveland groups collaborated in a plan to redo the old Coast Guard station. While financing is being sought, new access has been provided to the West Pier, which is now nearly connected to the Ohio and Erie Canal Corridor that extends from New Philadelphia to downtown Cleveland.

The pictorial record of Cleveland's lighthouses has been greatly enhanced by the numerous postcards of Lake Erie events that have been preserved. Steamer passengers in the 1900s found their ships surrounded by a variety of interesting vessels as they entered or left the Cleveland harbor. Tugs, fireboats, and freighters were always nearby. Other scenes may have been surfmen from the lifesaving service practicing boat-handling skills or conducting a missing-person search, lighthouse keepers rowing to a pier to service the lamps, a yacht race in process, or a couple of fishermen seeking the hot spot for perch or walleye.

Those who take excursion tours of the Cleveland harbor today have similar views, minus the surfmen and lighthouse keepers, but include some newer features such as Jet Skis, kayaks, sculls, dragon boats, or tall ships. The only time activity slows in the Cleveland harbor is when the navigation season is closed, between late November or December and March.

Today the success of the Port of Cleveland depends on the concerted arrangements of private enterprise, the State of Ohio, the City of Cleveland, Cuyahoga County, and the federal government entities such as the Army Corps of Engineers, the Coast Guard, and U.S. Customs and Border Protection. Their plans and projects often conflict with the desires of humans, flora, and fauna to live at water's edge. The fog signal building on the West Pierhead will be removed from the pierhead in 2008 or 2009 in order to facilitate repairs to the pier. The East Pierhead lighthouse was among lighthouses offered to nonprofit organizations under the terms of the U.S. Lighthouse Preservation Act in 2007 and was made available for auction in September 2008. The West Pierhead lighthouse could be next. An account of their history will help them live on.

Here is a list of beacons and lighthouse sites presented in this book: Water Street (now West Ninth Street); East Pier; West Pier; West Breakwater, East End; East Breakwater, West End; West Pierhead; East Pierhead; and East Breakwater, East Entrance.

One

THE LIGHT ON THE HILL

The race was on. As soon as the Erie Canal across New York and the Ohio and Erie Canal across Ohio opened, the increase in ship traffic highlighted deficiencies at the mouth of Cleveland's Cuyahoga River and prompted efforts to improve the harbor's navigability. One such action was an $8,000 appropriation from the U.S. Congress in March 1829 for a lighthouse. In December 1829, Samuel Starkweather, collector of ports at Cleveland, signed a construction agreement with merchant-shipbuilder Levi Johnson and his partner, Steven Woolverton, for a lighthouse "to be completed by the first day in August 1830."

The site selected (over protests by many ship captains) was on a bluff overlooking the harbor, part of original lot No. 194 at the southwest corner of Water Street (now West Ninth Street) and Lighthouse Street (now Main Avenue or Lakeside Avenue). Although period landscape paintings confirm its prominence, it was also nearly a mile from the piers at lake level.

The height of the 1830 lighthouse has been described in conflicting ways through the years. However, the detailed government contract called for it to be built "55 feet above the surface and 25 feet in diameter, made of stone and whitewashed twice over." It was to have "a sufficient number" of circular (yellow pine) stairs to lead to within six feet of the lantern.

The contract also specified the lighting apparatus as 13 "patent lamps," each with a 14-inch silvered reflector, trivets, stands, and five double-tin containers to hold 90 gallons of oil each. Johnson and Woolverton also received the contract to build the accompanying dwelling house, outhouse, and well.

Conceding to mariners' requests, a scaffold-type beacon light was placed on the East Pier of the harbor in 1832. This light was replaced with a substantial cast-iron tower in September 1851, after the superintendent of lighthouses deemed the 1830 lighthouse "insufficient." Both towers operated daily during navigation season for more than 20 years, except for a 3-year period in the 1850s when the 1830 lighthouse was darkened to save money.

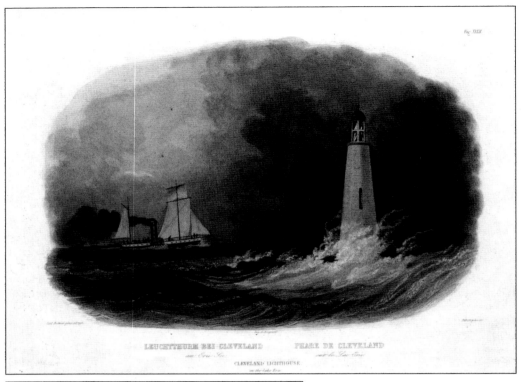

LEUCHTTHURM BEI CLEVELAND
am Erie See

PHARE DE CLEVELAND
sur le Lac Erie

CLEVELAND LIGHTHOUSE
on the Lake Erie

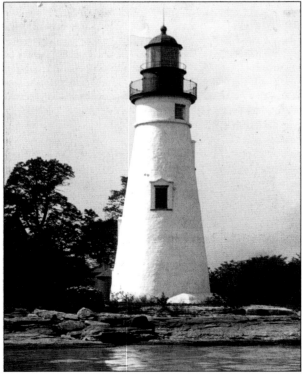

One of the earliest depictions of Cleveland's first lighthouse is an 1843 aquatint painting (above) by Karl Bodmer, printed following the artist's trip throughout the western United States with his patron Prince Maximilian zu Weid-Neuweid of Prussia. However, the Swiss artist must have made a naming mistake, as the waves of Lake Erie could never have lapped against the Cleveland lighthouse, which was on a 70-foot bluff. It is likely that Bodmer actually sketched the Sandusky lighthouse (left), which is 80 miles west of Cleveland. Now called Marblehead Light, it was built in 1820 on stony slabs close to the lake and is the oldest continuously operating lighthouse on Lake Erie. Today it is open to the public as the centerpiece of Marblehead State Park. (Above, Rare Books Division, Special Collections, J. Willard Marriott Library, University of Utah; left, CSU.)

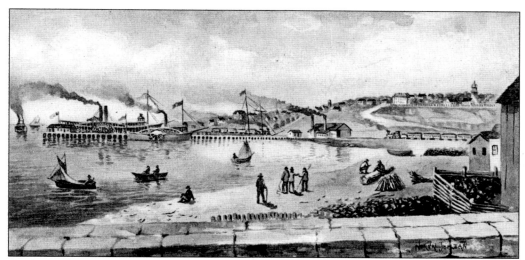

Coal merchant John G. Stockley operated a business from a pier on the west side of the Cleveland harbor in the mid-1800s. An artist produced a drawing of the city of Cleveland from that vantage point, including the first lighthouse as one of the prominent features. Across the way on the eastern pier were the United States government's Beacon 1 and the tracks of the Ashtabula Railroad. (CSU.)

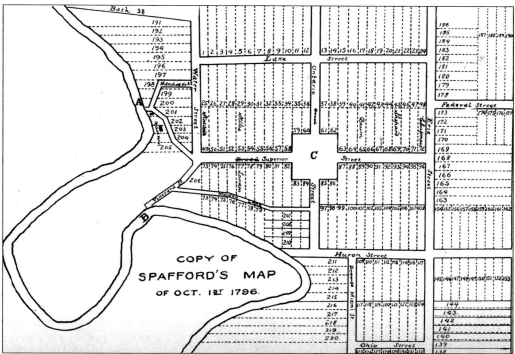

Despite its crooked nature, the Cuyahoga River became an important site for a major port and harbor at Cleveland. Its silty, sandy conditions presented constant challenges to harbor operations. Amos Spafford, a member of the original surveying team with Moses Cleaveland, is credited with preparing an 1814 town map. Samuel Orth included this version of the map in *History of Cleveland*, published in 1910. (CSU.)

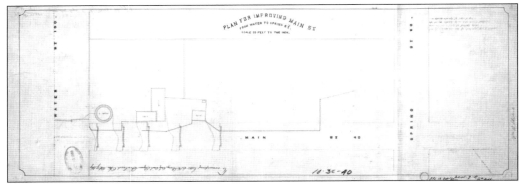

Although this plan is dated 1869, it fits this chapter because it shows the arrangement of buildings around the first lighthouse. The proposed street work (which did take place) took 10 feet from the lighthouse property. Terraces were constructed, and the original Lighthouse Street was straightened into an extension of the former Lake Street, by then renamed Main Avenue. (NARA.)

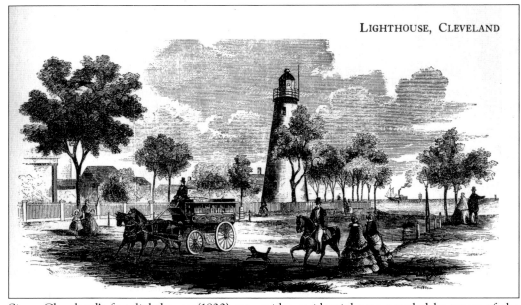

Since Cleveland's first lighthouse (1830) sat amid a residential area peopled by many of the village's founding families, strolling couples and hurrying carriages would have been typical. However, the artist took liberties with the scene by showing the lake level at the end of the street. The lighthouse was actually on a 70-foot bluff on the east side of the Cuyahoga River, nearly a mile from the harbor piers. (Author's collection.)

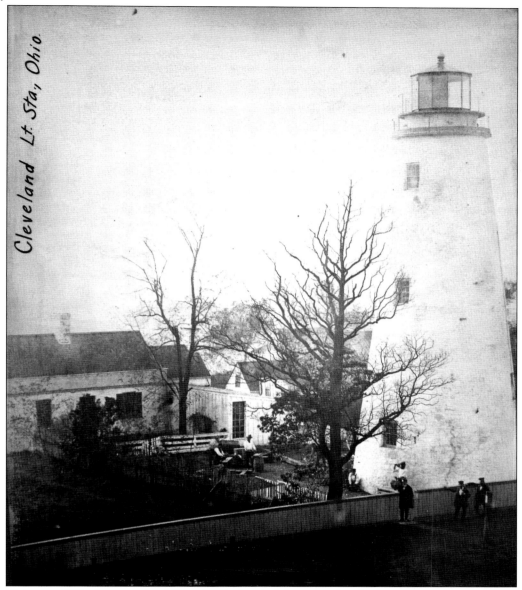

Cleveland Lt. Sta., Ohio.

This rare 1859 photograph of Cleveland's first lighthouse, taken looking west, also provides a view of the keeper's house and outbuildings surrounded by a board fence. Keeper James Farasey, who served from 1857 to 1861, is likely to be one of the men standing beside the fence. He and his family lived just steps from the lighthouse in a two-room stone house with an attached kitchen. The house also had a stone and brick cellar, and there was a boarded, shingled, and painted outhouse nearby. The simplicity of the facilities is clear from the contract specifications for the kitchen, which was to have a sink "with a gutter to lead through the walls out of the house" as well as an outdoor chimney with an oven of "middling size." These structures served Cleveland for more than 40 years. (NARA.)

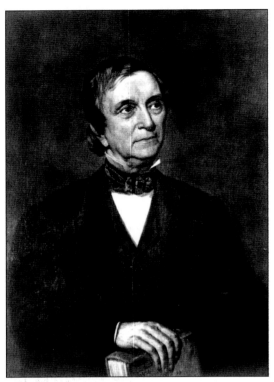

Samuel Starkweather (1799–1876) served as collector of customs and superintendent of lighthouses at the port of Cleveland from 1829 until 1840. He oversaw the building of Cleveland's first lighthouse and appointed its first keepers. In the early 1800s, the customs officer also administered the U.S. Revenue Cutter Service for the U.S. Department of the Treasury. (CSU.)

The following shows the number of vessels entered and cleared at the port of Cleveland with cargoes, and their aggregate tonage from A.D. 1825 to August 1st 1835

	Nº of vessels arrived with cargoes	Nº of vessels cleared with cargoes	Aggregate tonage of vessels arrived with cargoes	Aggregate tonage of vessels cleared with cargoes	Nº of vessels arrived from foreign ports	Nº of vessels cleared for foreign ports	Nº of Steam Boats arrived	Nº of Steam Boats cleared	Total Nº of arrivals including Steam Boats	Total amt of tonage arrived including Steam Boats
1825	54	54	2060	2060	1	1	21	21	75	7310
1826	63	63	2835	2835	4	4	42	42	105	13135
1827	75	75	3000	3000	11	11	63	63	138	18750
1828	92	92	4140	4140	4	4	70	70	162	21640
1829	222	222	8880	8880	7	7	90	90	314	31300
1830	327	327	15489	15489	2	2	448	448	775	127489

Maritime industries grew quickly in Cleveland as harbor improvements were made to provide sufficient channel depth and dockage. This chart details arrivals and departures during the period of 1825 to August 1, 1835. The dramatic changes in the 1830s are a result of increased shipping once the Erie and the Ohio and Erie Canals were connected to Lake Erie. (CSU.)

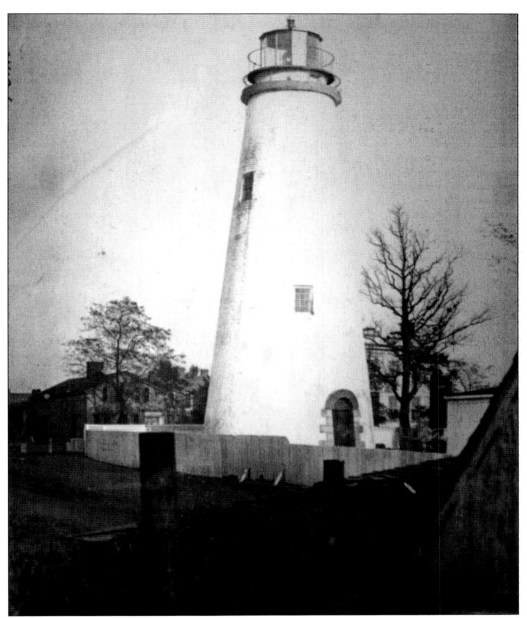

The second of two rare photographs of the 1830 lighthouse taken in October 1859 shows the three-story stone structure that was 55 feet tall and 25 feet in diameter. It stood high on a bluff at the southwest corner of Water Street (now West Ninth Street) and Lighthouse Street (renamed Main Avenue). The black, wrought iron lantern held 13 patent lamps with 14-inch silvered reflectors that burned sperm oil to provide nightly illumination during the months that Lake Erie was navigable. The lighthouse and related buildings cost $8,000 to build and equip. The contract specifications stated that the walls of the lighthouse were to be five feet thick at the base, graduated to two feet thick at top. The wrought iron lantern (the portion containing the lighting apparatus) was to be "glazed with double glass from the Boston factory" and topped with a "traversing ventilation" on the dome. (NARA.)

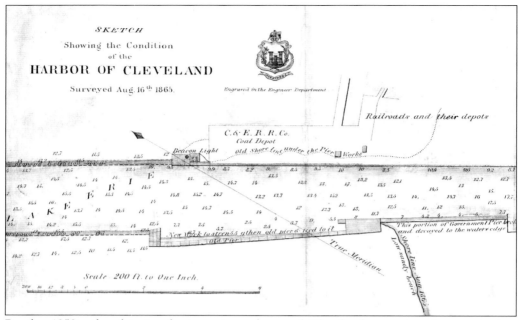

By the 1850s, the shipping business in and out of Cleveland necessitated many harbor improvements. This map was drawn by U.S. Army engineers in 1865 to describe the need for extended piers on both sides of the Cuyahoga River. The existing scaffold-type tower, called Beacon 1 for many years, is represented by a black dot on the East Pier. (CSU.)

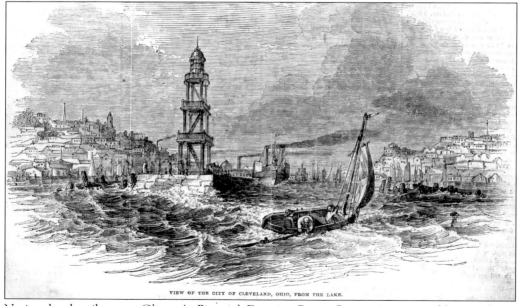

National subscribers to *Gleason's Pictorial Drawing Room Companion* were able to admire Cleveland's fine beacon light when this sketch appeared in the January 24, 1852, issue. Observant readers also located the "lighthouse on the hill" at left. The first keeper, Steven Woolverton, complained to his superiors about the extra duty this beacon created for him because of its distance from the main lighthouse. (Author's collection.)

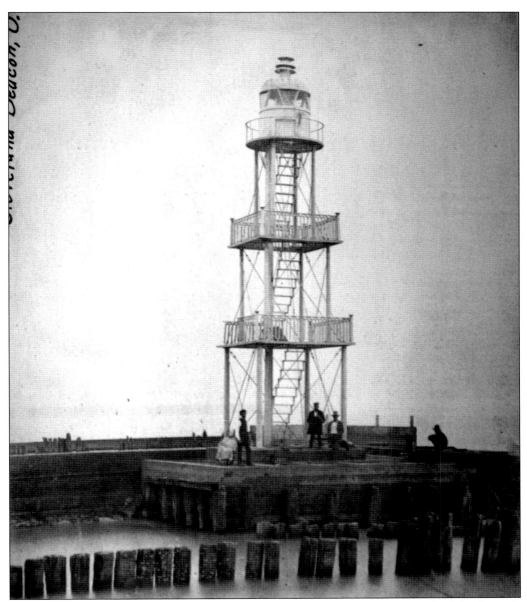

To appease ship captains who had lobbied to have a lighthouse right at the harbor, the U.S. government erected a scaffold-type iron beacon in 1831–1832 on the pier east of the Cuyahoga River. Now ships arriving at Cleveland used the lighthouse on the hill as a general guide and the beacon light (which was 32 feet tall) to define the channel entrance. Lighthouse keeper Steven Woolverton complained frequently about the challenge of servicing this structure. In 1833, he wrote to his superior that he had employed his 17-year-old son and four different men to tend the beacon while he remained in the tower. He described the circumstances: "The lamp must be trimmed or snuffed about twelve o'clock at night, and if a sudden storm of wind would cause the sea to break on the pier, he could not get to the beacon and the lamp would go out before day." Woolverton did eventually receive an increase in pay to cover the expenses of extra help. (NARA.)

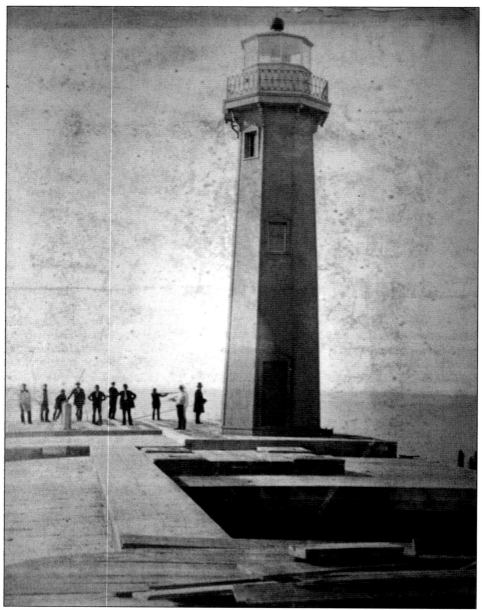

In 1851, the iron scaffold-type beacon on the East Pier was replaced with a 40-foot hexagonal cast-iron structure with a sixth-order fixed lens that also burned sperm oil, like the old lighthouse on the hill. Several different lighting systems were tried in a short span of time. In 1854, the lighthouse board inspector reported that "the Cleveland light is of but slight importance since the new apparatus . . . has been introduced into the pier-head light." Consequently, Congress agreed to discontinue the lighthouse on the hill in 1856. One can only imagine the political activity that must have occurred in the next few years to prompt Congress to give the authority to re-exhibit a light from the lighthouse tower on the hill at Cleveland in 1859. Whatever the reasons, this did all occur soon after a major reorganization period for the U.S. Light-House Board and in an era of heightened inspections of all the nation's lighthouses. (NARA.)

Two

VICTORIAN SPLENDOR

Cleveland's first lighthouse was replaced in 1871–1872 by an architectural wonder of brick and stone, just south of the old lighthouse and on the same property. The beacon in its 84-foot tower was visible 20 miles away, since the center of the lens was about 154 feet above the lake. Over the years, this magnificent structure changed size and shape. First, the two-family keeper dwelling was enlarged to accommodate two more assistants and their families. Then the tower portion was removed in 1895 after it was damaged in a nearby fire; its services were no longer needed when a lighthouse was placed directly in the harbor in 1885.

Other substantial homes were neighbors of the U.S. government lighthouse on the corner of Lighthouse Street in its early years. The dwelling continued to be home to the keepers and assistants until 1927. By then its high gabled roof contrasted markedly with the square, flat warehouses built in the vicinity.

After the keepers and assistants moved to two two-family homes on West Boulevard (even farther from the harbor), the old house was sold and used for storage until it was torn down in 1938 to make way for the new Main Avenue Bridge.

Few photographs (and no postcards) of this lighthouse were found while researching this book. Its location—nearly a mile from the harbor—made it oddly invisible, given its purpose. However, Lake Erie travelers would have been thoroughly familiar with structures at the ends of the piers at the mouth of the Cuyahoga River and many called them lighthouses even though they were beacons in U.S. Light-House Board terminology.

Memories of the long-gone High Victorian Gothic–style structure are retained in three existing lighthouses in the United States and Poland. The lens, lantern, and ironwork from the Cleveland lighthouse were moved to the identical tower of the Braddock Point, New York, lighthouse in 1896. The design of the dwelling portion of the Cleveland lighthouse was copied at South Block Island, Rhode Island. The tower was also replicated in Gdansk, Poland, in 1893.

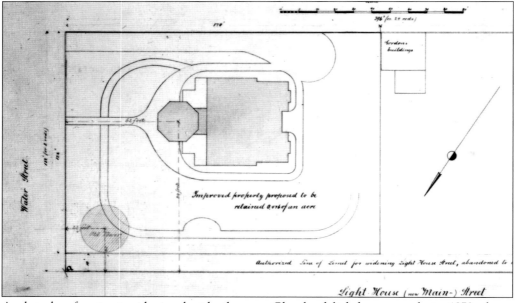

A plot plan for street widening beside the new Cleveland lighthouse, made in 1873, shows the new structure with its attached duplex keepers' dwelling and the outline of the original 1830 lighthouse. The drawing also shows buildings belonging to neighbor W. J. Gordon that had encroached on unused parts of the lot. Gordon later relinquished these to the U.S. government. (NARA.)

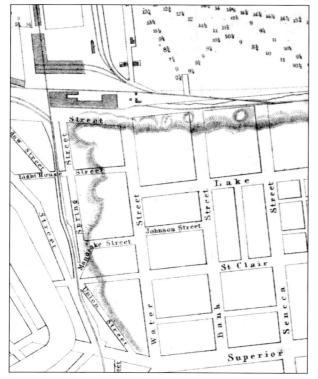

The first two Cleveland lighthouses were located at the southwest corner of Water Street and Lighthouse Street. Lighthouse Street was rebuilt and renamed Main Avenue, to connect via a bridge with the street of the same name to its west. Main Avenue essentially disappeared with the construction of a major highway and bridge. Today the former lighthouse property can be found where Lakeside Avenue intersects with West Ninth Street. (CSU.)

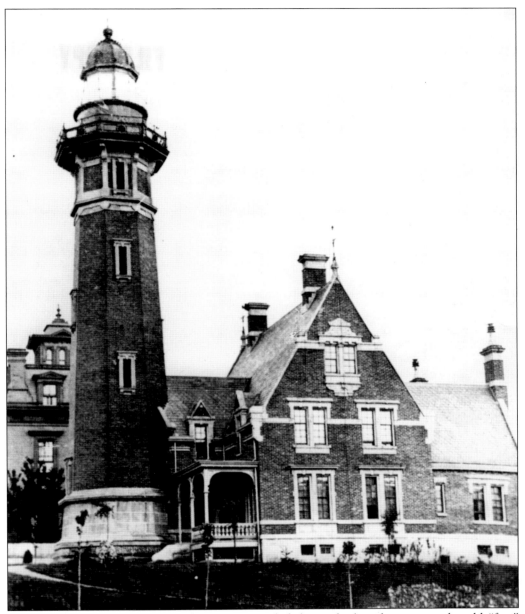

In 1872, Clevelanders were proud to see a new lighthouse built right next to the old "first" lighthouse at the corner of Water Street (now West Ninth Street) and Lighthouse Street (later named Main Avenue and now Lakeside Avenue). Constructed of brick and stone in High Victorian Gothic style, the 84-foot tower was attached to a two-family dwelling. Its comfortable piazza was painted light buff with dark vermilion chamfers. The original specifications called for the ceiling to be painted light blue and the latticework dark "Paris Green." The cost for building this station was $55,775. Its steeply pitched roofs and prominent window heads are notable characteristics of its architectural style. (CGHO.)

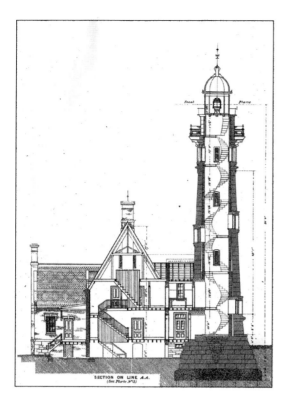

Imagine climbing seven stories of circular stairs at least once every night and every morning to keep the oil lamps operating properly. When the 1872 lighthouse was built, the two resident keepers lived in the attached quarters. By being built on a 70-foot bluff, the light had a focal plane of approximately 154 feet. It had a fixed white light with a range of 20 miles. (NARA.)

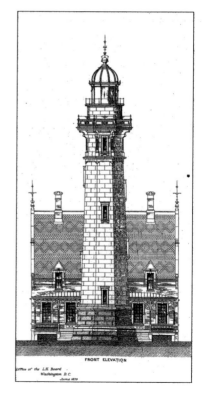

This architectural drawing for the tower of the Cleveland lighthouse shows stone as the building material, but stone was very hard to obtain because of the rebuilding taking place in Chicago after the Great Fire of 1871. Even purchasing brick for this lighthouse was a challenge. It was eventually secured from a New York supplier rather than an Ohio firm. (NARA.)

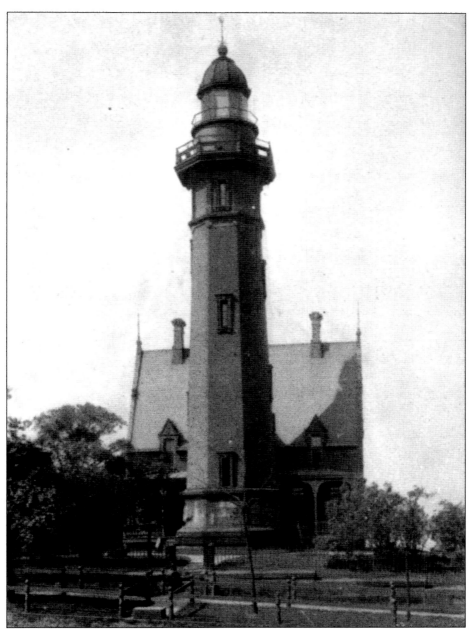

Viewed from the front, the 1872 lighthouse seems to dwarf the keepers' dwelling. The 84-foot tower was built on a sturdy stone base 20.5 feet wide. The walkway around the lantern was used by keepers to clean the lantern glass, a very frequent duty in an industrial city. The lantern contained a three-and-a-half-order lens with a fixed white light that was operated until the close of navigation in 1892. In 1895, the tower portion received some damage from fire in neighboring properties, and it was removed from the dwelling later that year. Its lantern, lens, and ironwork were taken to New York and installed on the Braddock Point lighthouse. An addition had been built on the dwelling in 1885, and the four families of lighthouse service employees continued to live there for more than 30 years after the tower was removed. (BGSU.)

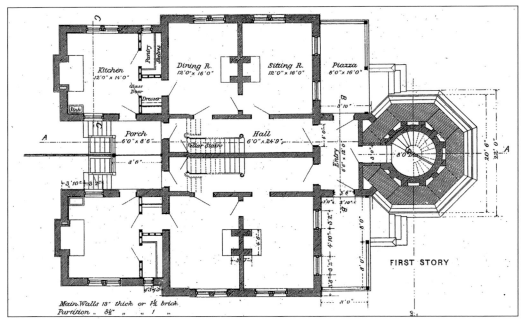

As originally designed, the first floor of the 1872 lighthouse had mirror-image apartments for the keeper and assistant keeper with a kitchen, pantry, dining room, and sitting room for each unit, plus a front piazza, a back porch, and hallways. Rooms were spacious and the walls were 18 inches thick. (NARA.)

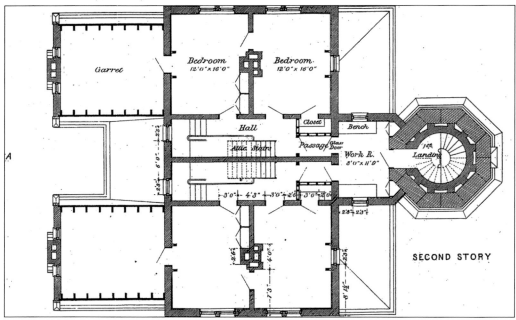

Bedrooms, each 12 feet by 16 feet, dominated the second floor of the mirror-image apartment. The two keepers could access the tower workroom through doors from their individual apartments. Bathrooms are not shown on the plan; keepers and their families used an outhouse until a remodeling took place in 1885. (NARA.)

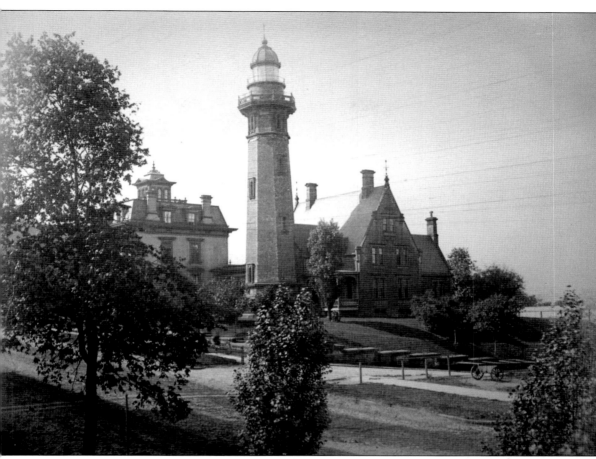

The keepers' dwelling on West Ninth Street had a much longer life than the lighthouse tower itself. A light was maintained in the tower until 1891, even after a lighthouse was added to the West Breakwater in 1885. An addition was made to the dwelling in 1885 so that it would accommodate four families. A major fire broke out at a box factory near the West Ninth Street property in December 1894. The substantial brick house with its 18-inch-thick walls was not harmed, but the glass panes of the lighthouse lantern were cracked from the heat produced by the fire. The next year the tower was removed from the dwelling, and the front porch was remodeled to extend across the area where the tower had been attached, as shown above. The dwelling continued to serve as home to the U.S. Lighthouse Service employees for another 32 years, then was purchased by Cuyahoga County and used mainly for storage for several more years. It was demolished in 1936 to make way for the new Main Avenue Bridge. (CGHO.)

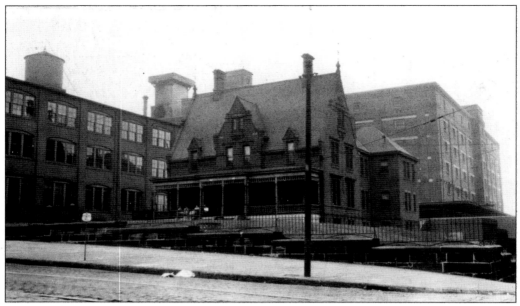

This photograph of the keepers' dwelling minus the tower also shows the addition that had been built on the rear of the structure in 1885. By now the house was surrounded by commercial warehouses. The stone wall in front of the house was added soon after the lighthouse was built in 1872. (CGHO.)

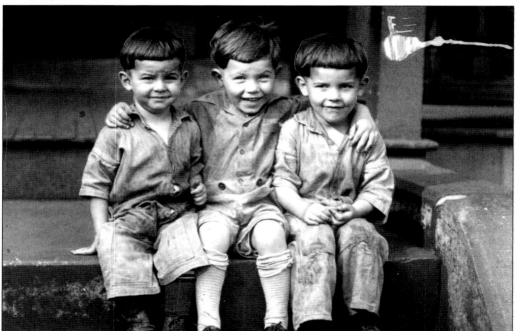

The front porch of the keepers' dwelling must have been a great place to play. Posing there on the steps in September 1927 are, from left to right, Francis Price, Bobby Perry, and Richard Price. The Price brothers were grandsons of assistant keeper Joe Price, and Bobby Perry was the son of keeper Charles C. Perry. (CSU.)

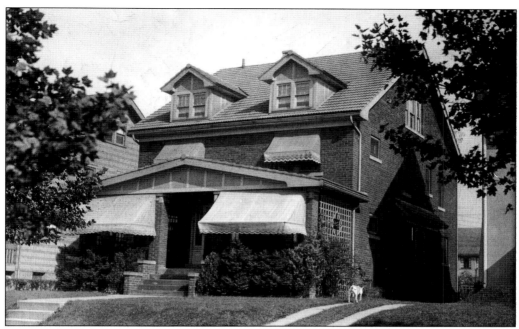

Two two-family homes were purchased on West Boulevard in Cleveland in 1927 for the keepers. One (pictured above) was at 2099–2101 West Boulevard and was purchased for $23,500. The address of the other two-family house (below) was 2093–2095 West Boulevard, and it was purchased for $19,000. Now the keepers' commute to and from the lighthouses and other navigational aids was even lengthier. They could drive to the piers (or take public transportation) but still had to use boats to get to the pierhead lighthouses and the East Entrance fog signal. By this time, the harbor lighthouse was outfitted with provisions in case the keepers were caught there in bad weather. (CGHO.)

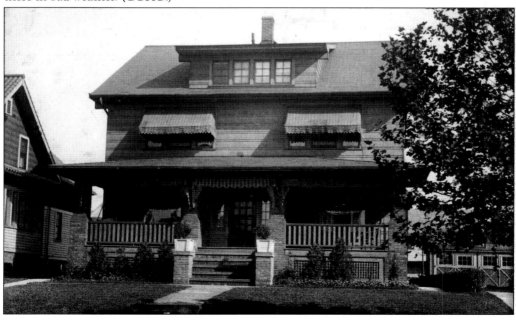

The lighthouse property at West Ninth Street and Lakeside Avenue experienced several encroachments over time as streets were widened and warehouses were built. In the 1932 photograph above, the forlorn keepers' dwelling is posted as "for sale." It was purchased by Cuyahoga County that year, even though demolishment seemed inevitable. While it was unoccupied, daring thieves climbed it to wrest copper gutters and other trim from the building. The 1939 photograph below was used to explain the path of the proposed four-lane Main Avenue Bridge to readers of the *Cleveland Press*. The dotted lines make it clear how the lighthouse and its property would be eliminated and how the National Terminals Warehouse would end up very close to the new highway. The new bridge replaced an antiquated two-lane drawbridge at the river. (CSU.)

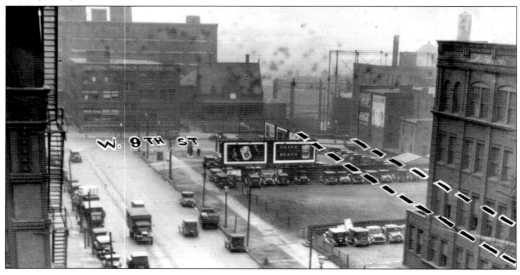

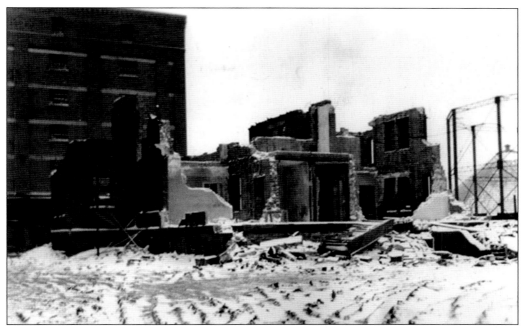

"Going, Going, Gone" could be the title to this 1938 photograph. The venerable building was being leveled for the construction of the four-lane Main Avenue Bridge (now called the Cleveland Memorial Shoreway and Ohio Route 2). In this view from the front, the frames of the front doors into the two-family keepers' dwelling are still standing. (CSU.)

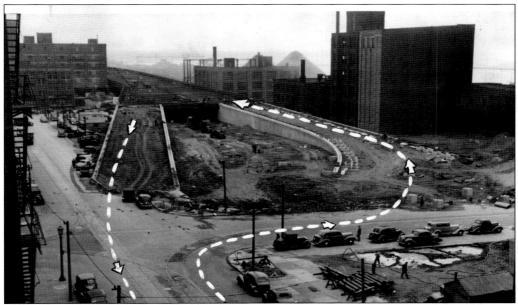

The old lighthouse keepers' dwelling has been leveled and the area is being used for parking by the time this photograph was taken of the new Main Avenue Bridge in progress. The National Terminals Warehouse, which had been built behind the keepers' dwelling, ended up being very close to the bridge and can be seen by eastbound travelers on the bridge today. (CSU.)

By comparing the location of the rooftop elevator housing in this 2008 picture to the same feature in the photograph on page 30, one can estimate the original location of the 1872 lighthouse. The space is now a parking lot for the National Terminals Warehouse Apartments; the overhead span of the Main Avenue Bridge looms to the north. (Photograph by Nathan Supinski.)

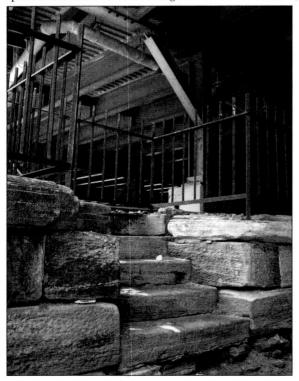

In 2008, all that remained of the 1872 lighthouse was a set of stone steps on West Ninth Street where the main Cleveland lighthouse was located for more than 70 years. The dressed stone in the adjoining retaining walls suggests that steps may have been built at a later date from part of the original base of the lighthouse or from the foundation of the keepers' dwelling. (Photograph by Nathan Supinski.)

In this photograph, the old Main Avenue drawbridge at river's edge is still in use but will soon be replaced by the new bridge looming overhead. The old drawbridge and its predecessor, a swing bridge, would have been the main route that lighthouse keepers took to go from their home on West Ninth Street to the West Pier where their boats were kept. (CSU.)

The Main Avenue Bridge that was built over the former lighthouse property on West Ninth Street is the front "ribbon" of highway that goes all the way across this photograph. The lighthouses were located near the center of the photograph, to the left of the river. This view also shows other bridges over the Cuyahoga River and some of the Inner Harbor dockage that was in place in 1968. (CSU.)

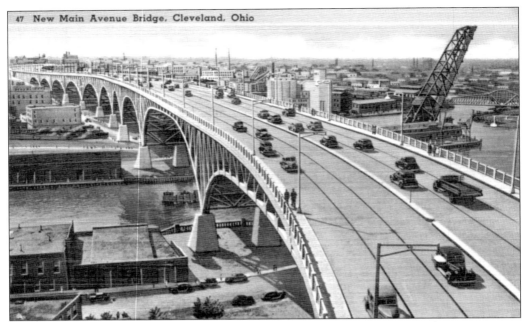

One of Cleveland's many grand bridges over the Cuyahoga River, the east end of the Main Avenue Bridge was built right over the site of Cleveland's first lighthouse. Its construction was partially a Works Progress Administration (WPA) project. This postcard view gives some indication of the steep drop of the former lighthouse property bluff site to the river's edge. (Author's collection.)

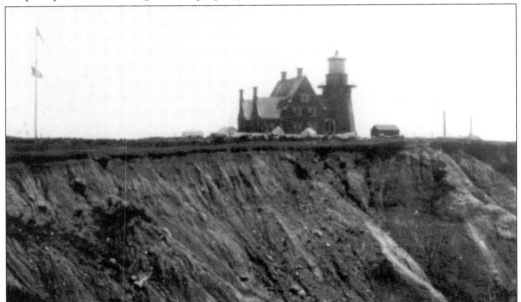

Although Cleveland's 1872 lighthouse was razed in 1895, its memory is retained in two U.S. lighthouses (and one in Europe). At South Block Island Light in Rhode Island, the dwelling is a copy of the Cleveland lighthouse, except that its chimney tops were extended in 1933. The 67-foot tower is a different design. This lighthouse was moved 250 feet from the brink of Mohegan Bluff in 1993. (Author's collection.)

The tower portion of Braddock Point Light on Lake Ontario in New York is a copy of the 1872 Cleveland lighthouse and even contains the lantern and ironwork that had been on the Cleveland structure. Originally 110 feet tall, as pictured, the tower has been shortened to 65 feet, and, with its one-family keeper dwelling, is privately owned. It is a mystery how the 1893 lighthouse in Gdansk, Poland, came to have an identical tower to Cleveland's. According to the bill of sale for the lens, a Polish delegation attended the 1893 World's Columbian Exposition in Chicago. No one knows if it saw Cleveland's lighthouse at that time or how it received the architectural drawings. (Right, CGHO; below, Gdansk Nowy Port.)

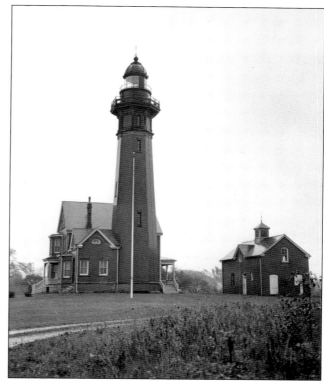

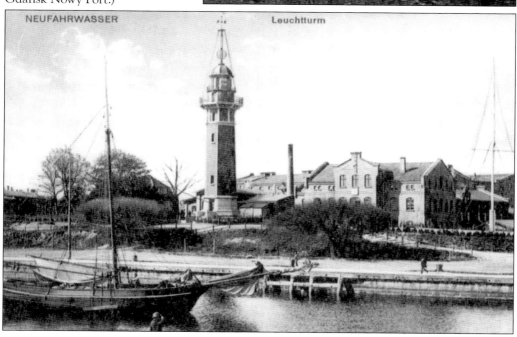

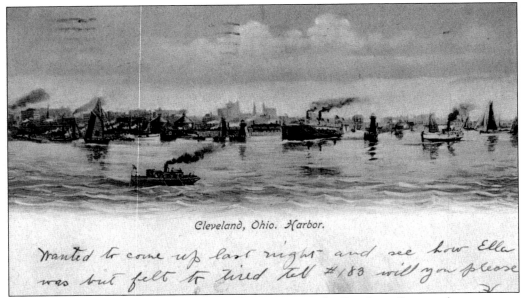

Cleveland, Ohio. Harbor.

Wanted to come up last night and see how Ella was but felt to tired tell #183 will you please

The beacons at the East and West Piers at the entrance to the Cuyahoga River underwent many changes through the years. In this postcard scene from the late 1890s, two wooden pyramidal beacons from 1875 are hard to pick out among the several kinds of ships leaving and entering the river. The West Pier beacon was replaced in 1901. The wooden East Pier beacon survived longer, into the 1930s. (CSU.)

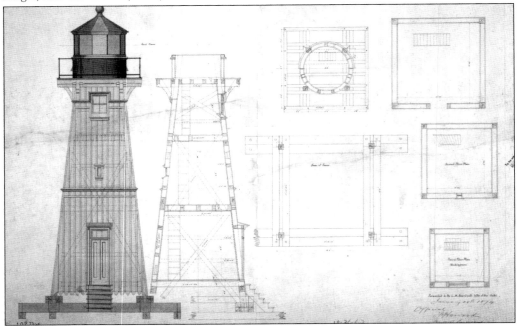

A three-story wooden structure topped with a traditional lantern was designed for Cleveland's West Pier and built there in 1875. By now, this was considered the primary beacon for the entrance to the river channel. The beacon shared the pier with the U.S. Life-Saving Service facility. (NARA.)

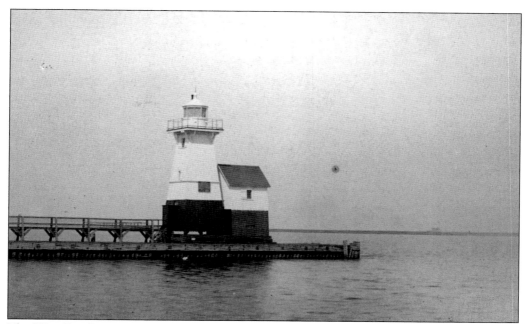

The West Pier beacon was painted brown below and white above and had a shed in front of it (painted the same colors) that held the fog bell. The long walkway usually suffered damage in the winter storms and made it too easy for vandals to tamper with the lighthouse system. This beacon had a sixth-order fixed white light. (NARA.)

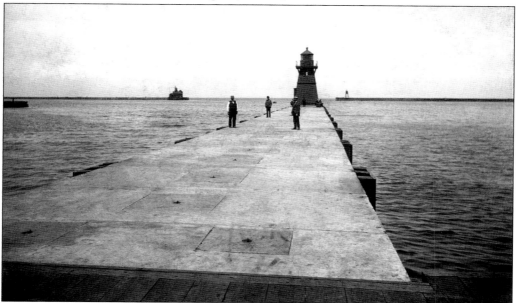

By the 1890s, the demands of a burgeoning shipping industry brought changes to the lifesaving service and the U.S. Lighthouse Service. More employees were needed in both agencies; the lifesaving service had outgrown its facility. The West Pier was rebuilt in concrete and a new building was erected. Shortly after this photograph was taken, the wooden beacon was replaced with a cylindrical metal one. (GLHS.)

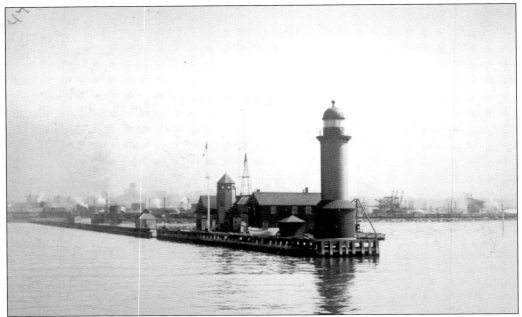

This photograph of the West Pier prominently displays the cylindrical beacon light that was in use for about 16 years. It was already in place when the U.S. Life-Saving Service became the Coast Guard in 1915. The beacon had a fixed white sixth-order light at first, then was replaced with a fourth-order flashing light in 1907. (NARA.)

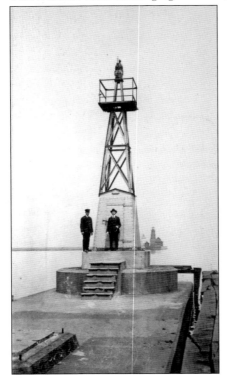

The skeleton tower that was placed on the end of the West Pier in 1917 had a small ironclad workroom at its base. Dimly visible in the background are the 1885 lighthouse on the West Breakwater and the 1911 lighthouse on the pierhead. The tower may have been simple to maintain, but it was challenging to mount its steps and enter during bad weather. (NARA.)

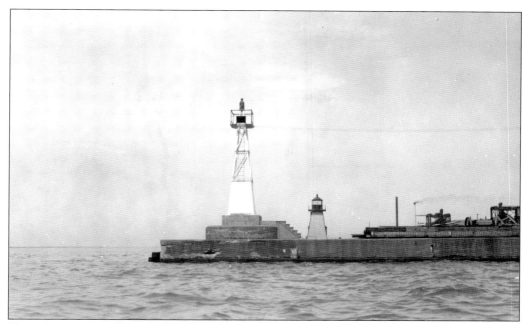

This photograph, taken in the 1920s from the harbor side of the West Pier, shows both the skeleton tower on the West Pier and the wooden beacon on the East Pier. A freighter is exiting the channel between them. For many years in the 1850s and 1860s, the East Pier light was maintained by the railroads that leased the pier from the federal government. (NARA.)

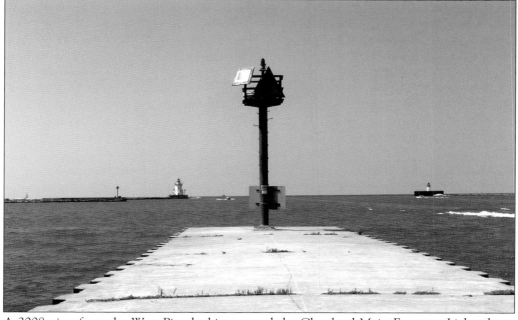

A 2008 view from the West Pier, looking toward the Cleveland Main Entrance Light, shows the pier's simple solarized post-type navigational aid with a flashing red light in the foreground. An identical structure is on the East Pier today exhibiting a flashing green light. The posts are 29 feet high. (Photograph by Nathan Supinski.)

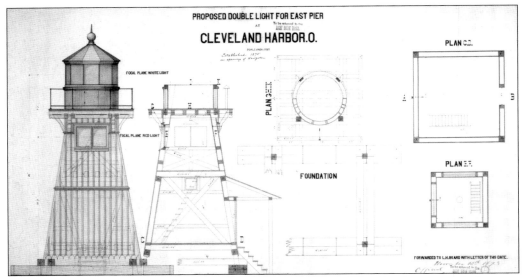

The double-light East Pier beacon was built the same year as the West Pier beacon with the same materials. It had a similar shape but was shorter (30 feet tall) and had two floors, not three. It continued the double-light scheme that had been in use for years. A white light was displayed from the lantern on top; a red light shone from the window below the lantern. (NARA.)

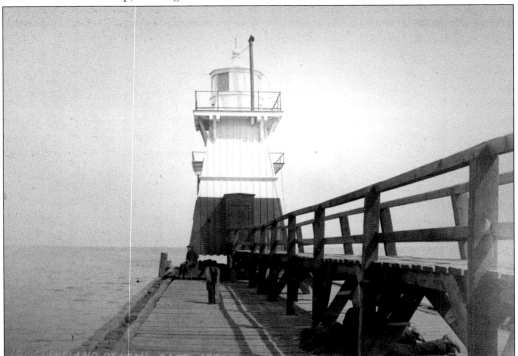

When this photograph was taken in 1885, keepers made nightly trips to the 575-foot-long East Pier to ensure that its mineral oil lamps and sixth-order flashing red and white lamps were functioning properly. It was never an easy assignment, and the walkway at least provided handholds in windy, rainy conditions. (NARA.)

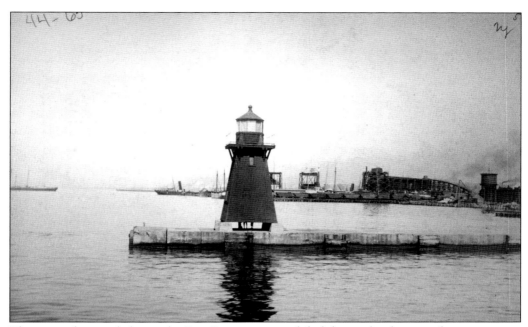

The square beacon light on the East Pier was painted dark brown by the time this picture was taken in 1904, no doubt to make it easier to see through the smog and smoke that permeated this active industrial and commercial site. The wooden catwalk had been removed earlier when it became easier for keepers to row a boat to this location than to walk. (NARA.)

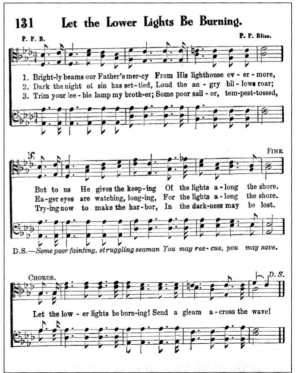

A well-known hymn has a curious Cleveland connection. Philip Peter Bliss (1838–1876) wrote "Let the Lower Lights Be Burning" in 1871 after hearing a parable related by the renowned Chicago evangelist Dwight L. Moody. The story told of a ship captain seeking the Cleveland harbor but not being able to see the "lower lights" (the lights on the piers at water's edge) and crashing upon the rocks. (Author's collection.)

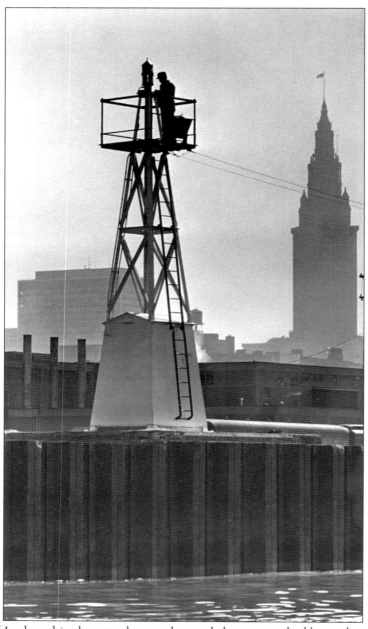

By March 1964, when this photograph was taken, a skeleton tower had been placed on the East Pier. Coast Guard engineman Peter De'Amico had climbed to the top to be sure that the signal light was ready to work for the opening of the navigation season. This was one of seven harbor lights that the Coast Guard maintained. In the 1960s, the Cleveland Coast Guard station was staffed with 21 men. A typical work schedule was two complete days on and an evening off the third day. It was not unusual for coastguardsmen to put in more than 80 hours each week during the active pleasure-boating season when patrol, search, and rescue missions could not be timed to precise schedules. The men were expected to take their own vacations during the winter months when the harbor was closed to navigation. (CSU, photograph by Jersy Horton.)

Three

THE LIGHTHOUSE THAT WOULD NOT SIT STILL

The pictorial record is as skimpy for Cleveland's most troublesome lighthouse as it is for its Victorian predecessor. Initially it seemed inspired to reuse a decommissioned lighthouse to illuminate the Cleveland harbor's entry point at the new West Breakwater area. However, the bulky brown structure that was moved to Cleveland from Rochester, New York, in 1885 did not settle easily into its new environment. The 1889 report of the lighthouse board was ominous: "During heavy blows, the crib shakes so violently and inclines from the vertical so much as almost to stop the revolving apparatus of the light. Extra weights are required, and on one or more occasions the keeper has been obliged to revolve the lens by main strength."

Some 700 cords of stone riprap were reworked into the crib between 1894 and 1901 to improve the underlying pilings. Once the foundation difficulties were under control, a plan was made to improve navigation by increasing the height of the West Breakwater lighthouse. In August 1903, it was raised some 20 feet, an amazing engineering feat.

The breakwater lighthouse brought big changes to the workload of the lighthouse keeper and assistants. Not only did they need to keep both the 1872 lighthouse and the West Breakwater lighthouse lit nightly during the navigation season until 1892, but they had to row boats back and forth to tend the fog signal, the East Breakwater light, and lights at the piers.

As Cleveland's industrial fortunes grew, so did a fog, or smog, problem that frequently obscured the lighthouse signal and the other beacons. Several kinds of fog bells and whistles were tested, first at one location, then another.

Lake Erie's proclivity for sudden storms contributed to numerous accidents near the West Breakwater lighthouse. One such incident in 1890 earned keeper Frederick T. Hatch the singular distinction at that time of receiving two lifesaving awards. Hatch (a former surfman with the U.S. Life-Saving Service) climbed along the breakwater stones to rescue a member of the crew of the lumber schooner *Wahnapitae*. Sadly, one of the eight persons aboard died.

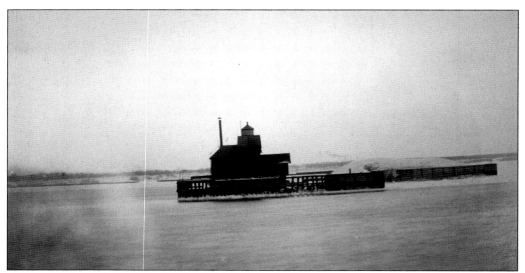

In October 1885, Lake Erie mariners had a new navigational aid—the Cleveland West Breakwater lighthouse. An octagonal cast-iron tower was brought to Cleveland from Rochester, New York, and installed on a 40-foot-by-40-foot crib (foundation structure) at the east end of the 6,048-foot breakwater. Its black lantern was equipped with a new fourth-order Fresnel lens made by Barbier and Fenestre of Paris, France. (NARA.)

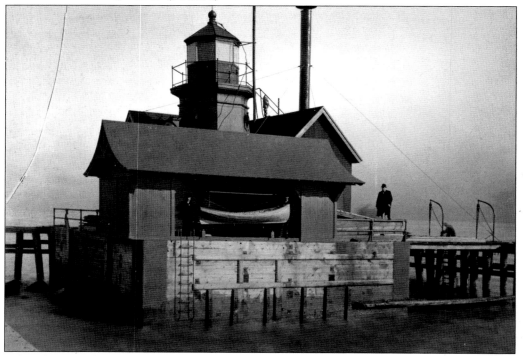

When first installed, the West Breakwater lighthouse had a 27-foot focal plane. It was placed on a breakwater that was not connected to the shore, so keepers had to row to the site. A boathouse with launching apparatus provided protection for the boat. Coal for the steam fog signal and oil for the light were delivered to the lighthouse by a 10th Lighthouse District tender. (NARA.)

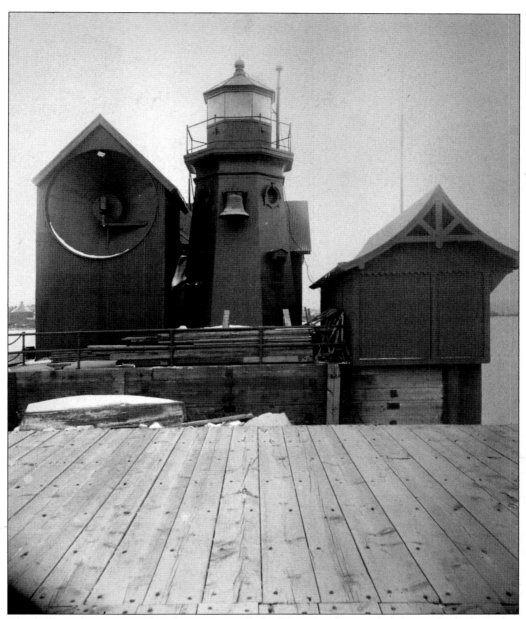

The hulking brown complex that comprised the West Breakwater lighthouse looked sturdier than it actually was. This photograph accompanied an engineer's report that was concerned with the tendencies of this lighthouse to sway during severe storms. The 1889 report of the U.S. Light-House Board stated that stones had washed out of the crib supporting the lighthouse due to broken or defective timber underwater and that the lighthouse was "quite shaky" during heavy gales. The tons of stone riprap added to the crib were only temporary resolutions to the problem. A row of strong piles was driven along the east and south faces of the crib to act as fenders against rafts or vessels and to protect the keeper's boat from hitting projecting tie-rods. In 1907, an appropriation request was initiated to replace this troubled light with a new structure on a new arm of the breakwater. (NARA.)

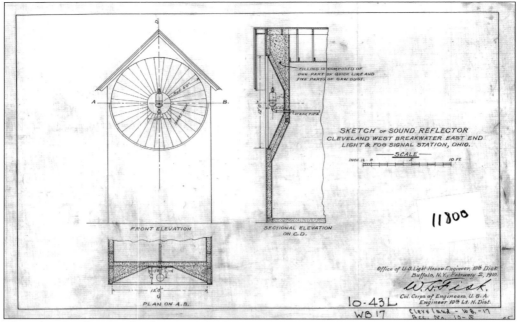

This plan for the sound reflector of the fog signal at the West Breakwater lighthouse calls for the use of quicklime and sawdust as filling behind the sheet iron dish. The steam-operated signal had been installed in 1890 but seemed to be too loud for residents and not loud enough for mariners. Later photographs show that a second whistle was added to produce a two-note sound. (NARA.)

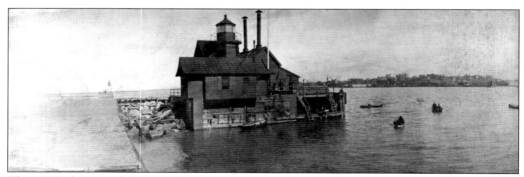

This 1895 photograph is part of a panorama of the West Breakwater lighthouse as viewed from the western side. A boat storage shed had been added to this side when the original boathouse was converted to keepers' quarters. By this time, there were four regular U.S. Lighthouse Service employees who worked shifts, routinely staying at the lighthouse through the night, or for several days, if the lake was unusually capricious. (GLHS.)

Augustin Fresnel of France invented a compound glass lens in 1822 that greatly improved the length of light beams in lighthouses. This chart describes the sizing and nomenclature for lenses that have been used on the Great Lakes. The West Breakwater lighthouse had a fourth-order lens that was nearly 20 inches in diameter. The pier beacons had smaller sixth-order lenses in the 1880s. (Terry Pepper.)

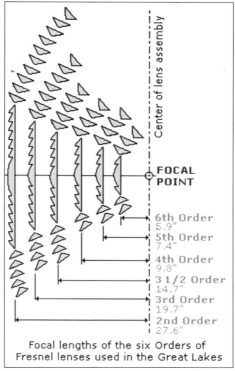

Focal lengths of the six Orders of Fresnel lenses used in the Great Lakes

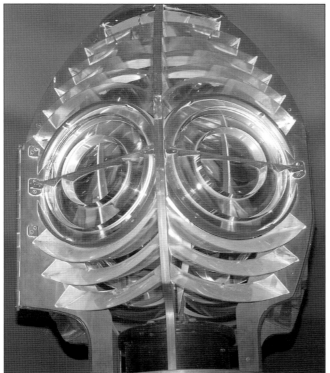

The fourth-order lens that served first in the 1885 lighthouse and later in a 1911 lighthouse was removed in 1995 but not retired. It was placed in an optics exhibit area of Cleveland's Great Lakes Science Center where it continually revolves and blinks to give patrons an idea of how the bull's-eye portions magnify a light source to provide a stronger beam. (Photograph by Nathan Supinski.)

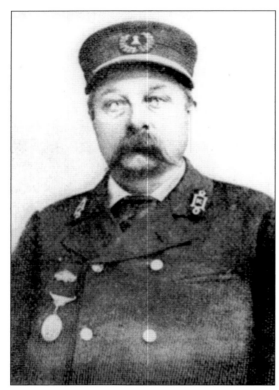

Frederick T. Hatch was keeper at the Cleveland lighthouse from 1895 to 1897. In 1891, he earned an unprecedented second Gold Life-Saving Medal for his rescue of the wife of the captain of the log boat *Wahnapitae*. Seeing the foundering schooner while on night watch on October 26, 1890, he launched a rowboat to assist those who had jumped from the boat. His boat capsized on his way back to the lighthouse, but he was able to pull Mrs. Hazen up a ladder to safety. Hatch was awarded his first medal as a U.S. Life-Saving Service surfman in 1883. The postcard of the tall version of the 1885 lighthouse shows the clockwork fog bell that was used if warnings were needed before the steam boiler could be heated to its required temperature. (Left, CGHO; below, CSU.)

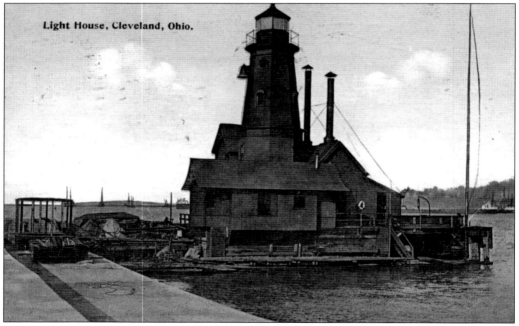

Light House, Cleveland, Ohio.

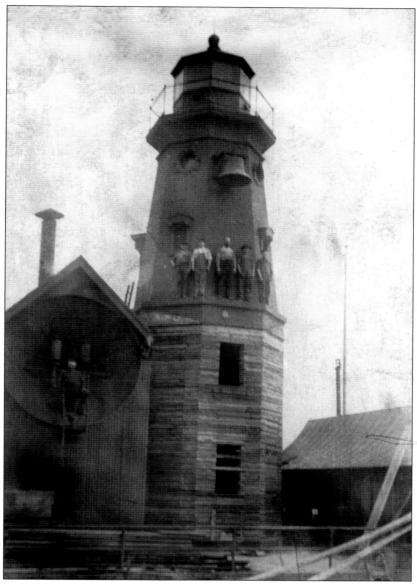

An amazing engineering feat was accomplished in 1903 when the West Breakwater lighthouse was raised 20 feet on a timber substructure in order to provide a more conspicuous light for ships in Lake Erie. Cast-iron lighthouses, such as this one, have been surprisingly mobile. This particular one had already made the trip to Cleveland from Rochester, New York, and now could be hoisted onto a taller foundation. Even with the improved visibility, some ships were still unable to avoid minor collisions with the lighthouse crib. Government reports in the 1890s detailed such accidents and described repair costs. Another expense for this station was coal to operate the fog signal. In 1898, the Cleveland station used the most coal of any lighthouse in the district—42 tons compared to 14 tons at the Detroit River lighthouse. An engineer's report of that era stated that "fog is one of the most tenacious enemies of safety on the Great Lakes." At Cleveland, climatic conditions and heavy smoke from steel mills and other manufacturing colluded to make the harbor unbelievably dense. (GLHS.)

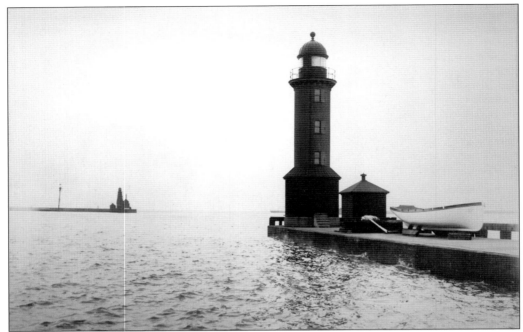

The photograph of the West Pier (above) illustrates the journey that was involved for the keepers' trips to the lighthouse seen in the distance. After 1885, keepers needed to stay at the lighthouse all night to manage the light and needed to be there in some daytime hours as well to do the cleaning of the lens and the windows. Another duty was to tend the lantern on the west end of the East Breakwater (below). This could only be reached by boat. In severe weather, the keeper might be unable to go to the light, even if it needed maintenance. (NARA.)

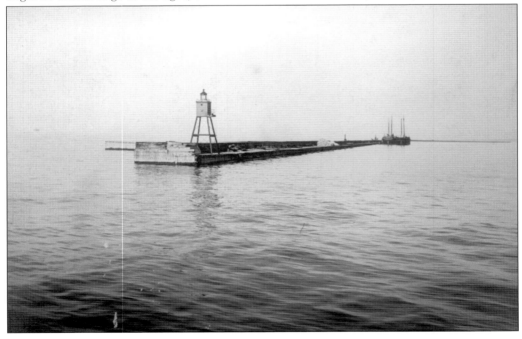

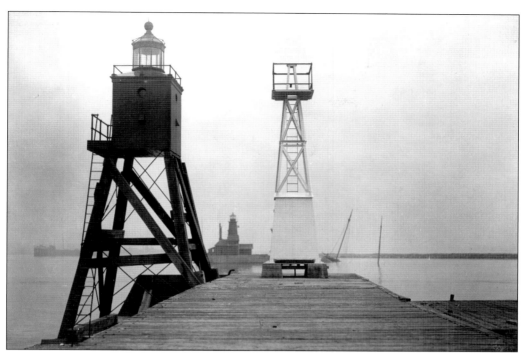

The west end of the East Breakwater had only a simple mast light when it was first under construction in 1887. Next a 30-foot stanchion tower was built, but severe ice formations caused it to deflect by about 20 inches so the mast light was refitted as before. By 1911, when the photograph above was taken, a steel skeleton tower had been added to the end of the breakwater. Its canvas enclosure at the base was all the protection afforded to equipment and workers. The photograph at right shows the same two towers in 1915, covered with ice, a condition that often prevented keepers from tending the oil lamps. (Above, CGHO; right, NARA.)

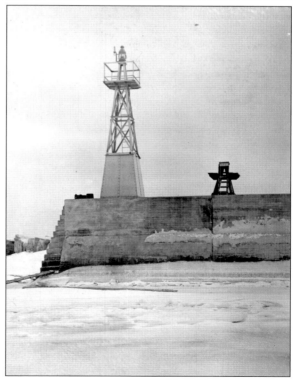

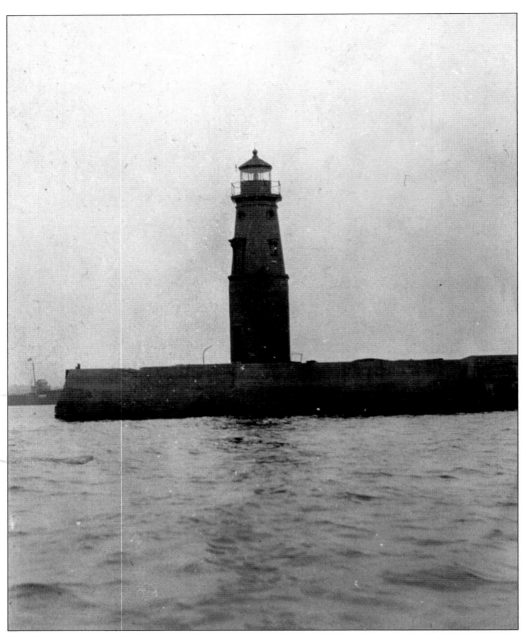

It is hard to believe that this tall tower was once a source of great concern because of its tendency to sway in windstorms. Many strategies were used to secure it to its foundation, and they were apparently successful because the tower remained on the east end of the West Pier long after it was a working navigational aid. The exact date of its removal has not been located, but it was still present in the harbor in a photograph dated 1921. The upper portion of this tower was originally built for a pier at the Genesee River harbor on Lake Ontario near Rochester, New York, but only resided there about three years before being relocated to Cleveland. It is unfortunate that no one seems to have preserved any photographs of it as it made its way to Cleveland, which may have been by barge. (NARA.)

Four

SISTER LIGHTS
ON THE PIERHEADS

By the early 1900s, the Cleveland harbor needed substantial changes to accommodate marine traffic boosted by demand for steelmaking resources. Ships were longer, wider, and heavier. Spurs, or pierheads, were added to the East and West Breakwaters to create a larger, more-protected entry to the Cleveland harbor.

In 1910–1911, new lighthouses were built on each breakwater pierhead—conical ironclad structures painted white—the longest lived of the harbor's many lights. They have pointed the way to and from Cleveland's docks every day, seven or so months a year, for almost 100 years.

The taller of the two lighthouses, named Cleveland Main Entrance Light on current Coast Guard maps, is called the West Pierhead light in older references. Its 55-foot tower has a focal plane that is 63 feet above the water.

The fourth-order Fresnel-type lens from the 1885 West Breakwater lighthouse was moved to the West Pierhead lighthouse and served there until 1995 when it was supplanted by a solar-powered lamp. Today the rotating beacon flashes alternating red and white lights every 10 seconds.

The smaller 25-foot lighthouse was built on the pierhead of the East Breakwater at the same time, and under the same federal contract, as the larger one. The East Pierhead light, with its distinctive green color, was automated in 1959 and now is solar powered.

In 1916, a second building was added to the West Pierhead for a foghorn and its steam boilers. The foghorn (not so affectionately called "the Cow") produced two blasts every 30 seconds when in use, penetrating 16 miles or more. Today the fog signal is solar powered.

In May 2007, the U.S. government accounting office offered several obsolete lighthouses to nonprofit organizations. The list includes the East Pierhead lighthouse at Cleveland. In September 2008, this lighthouse was placed up for auction. Time will tell whether this extinguishes the venerable lights in Cleveland's harbor or begins a lively restorative period to engage many more people in the history and lore of the lighthouses.

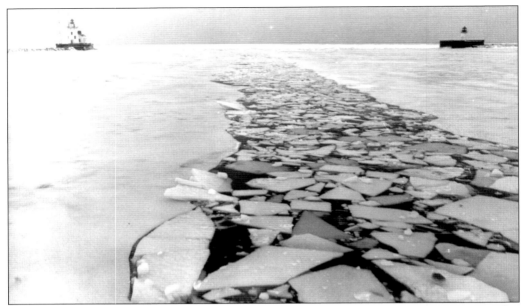

Cleveland's sister lighthouses seem especially remote when surrounded by ice as seen in this January 1968 view. Throughout their history, the lighthouses have been lit from sunset to sunrise, but only during navigation season, usually from March to December. However, some years Lake Erie does not freeze over, making it necessary to maintain the lighting schedule as long as there is ship traffic on the Great Lakes. (CSU.)

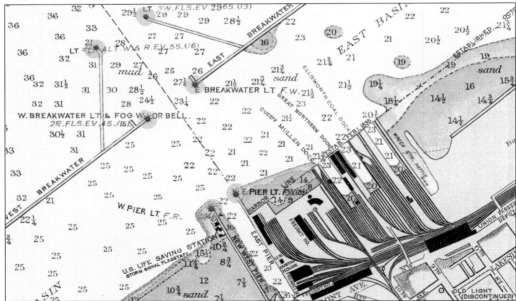

A 1911 navigational map shows the position of six of the seven lights and beacons that were needed to guide ships in and out of the Cleveland harbor. By 1911, the keeper had three assistants to coordinate the maintenance work for all facilities. The seventh site (East Entrance) is described later in this chapter. (National Oceanic and Atmospheric Administration, not for navigational purposes.)

The larger of the two Cleveland harbor lights—now officially named Cleveland Main Entrance Light—sits at the end of an arm extending from the West Breakwater. Accessible only by boat, this cast-iron structure had a kitchen and a bunk room to accommodate keepers who needed to stay overnight to maintain equipment or to wait out rough weather. (CSU.)

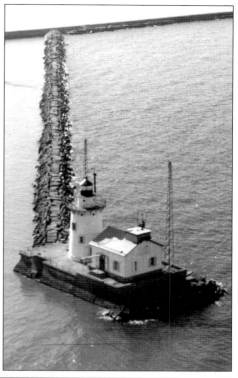

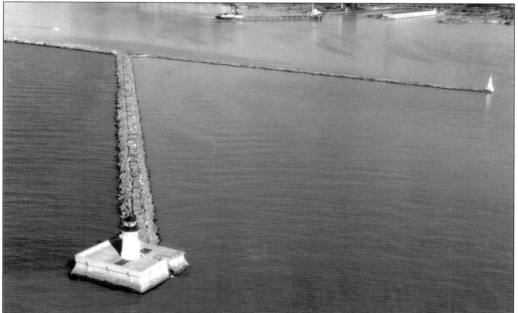

An aerial photograph is the best way to understand the placement of the East Pierhead light, which sits on a square crib at the end of a 1,250-foot arm extending from the East Breakwater, accessible only by boat. It originally held a fifth-order lens lit by acetylene that required keepers to visit the light regularly. The light was automated in 1959 and is now solar powered. (CGHO.)

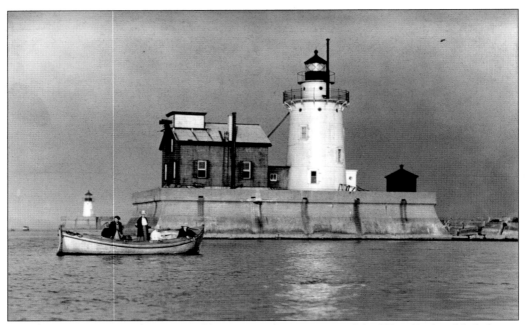

Five daring women in a boat were able to get a close-up view of the West Pierhead lighthouse one cloudy day in 1936. The East Pierhead lighthouse is visible in the distance at left. Since the pierhead lighthouses can only be reached by boat, they are still a curiosity to many harbor visitors. (NARA.)

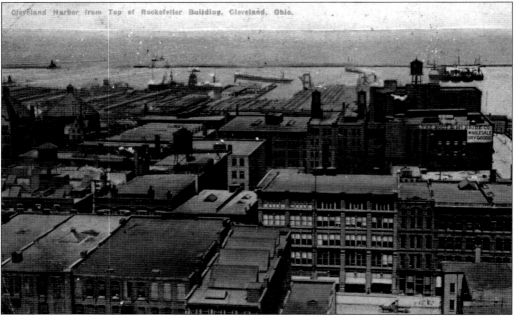

Near and yet so far, the Cleveland harbor lighthouses are the "front door" to ships arriving in Cleveland. This harbor panorama was photographed for a 1912 postcard from the top of the Rockefeller building, just a few blocks from the original U.S. government lighthouse on Water Street (now West Ninth Street) and Main Street (now Lakeside Avenue). (CSU.)

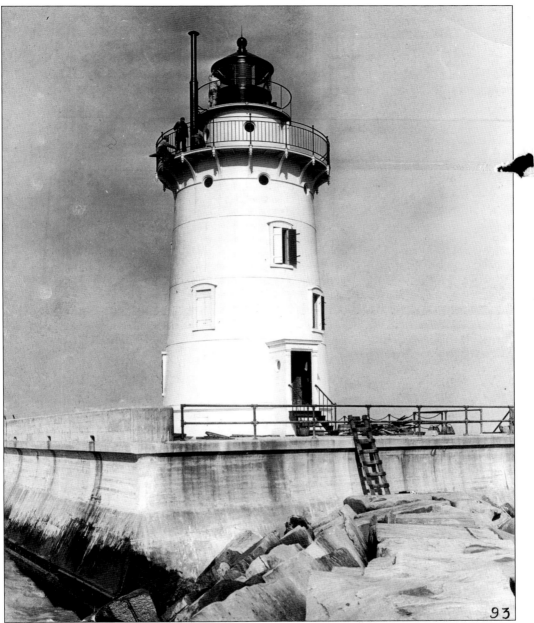

93

When first built, the West Pierhead lighthouse stood alone on its 60-foot-by-100-foot concrete deck. The lighthouse is 63 feet tall from its base to the center of its lens (focal plane). It has always been painted white with a black lantern and has a distinctive red roof. There are diagonal glass panes in the lantern. The light from the West Pierhead has always been a red and white flashing one, created by red panes placed over part of the lens. The sister lighthouses for Cleveland's harbor were built under a single contract in 1910–1911 for $45,000. They were first lit on March 25, 1911, an event that received no newspaper coverage because the pages of Cleveland's dailies were consumed with news of the devastating Triangle Shirtwaist factory fire in New York City on the same day. (CSU.)

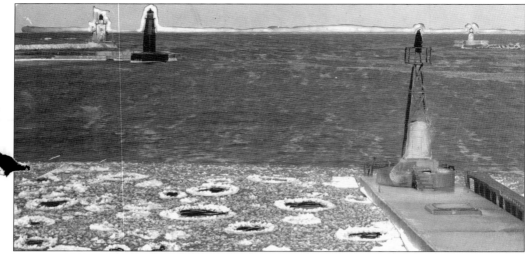

Between 1911 and 1917, or perhaps even later, ships arriving in the Cleveland harbor had three tall towers to help orient them to the entry channel. The 1885 lighthouse (minus its storage building, fog signal building, and keeper's quarters) remained in place for several years after the two 1911 lighthouses were in place and providing the official navigational signals. (CSU.)

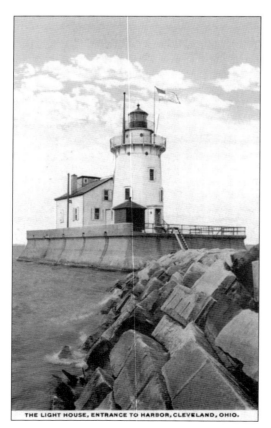

THE LIGHT HOUSE, ENTRANCE TO HARBOR, CLEVELAND, OHIO.

Who would not have enjoyed receiving this 1921 postcard of a Cleveland lighthouse? Artistically colored to show blue skies and even bluer water, the scenic view only hints at the remoteness of this lighthouse built on the end of a rugged rocky pier. The cover photograph for this book (minus the fishermen) appears to have been the source for this image. (CSU.)

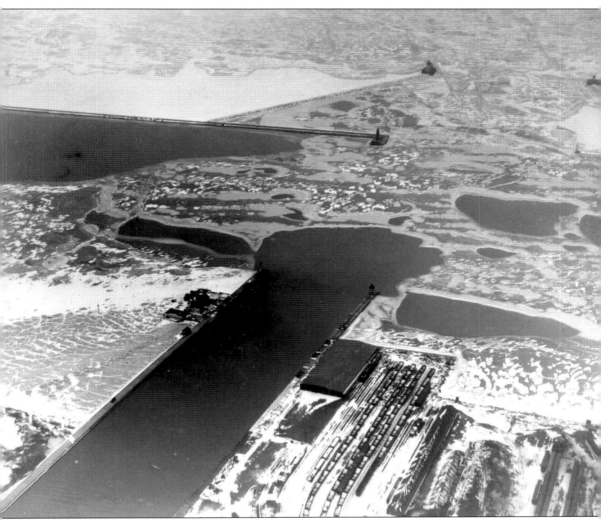

Snow and ice had descended upon the Cleveland harbor when this aerial photograph was taken in the early 1900s. The 1911 pierhead lighthouses are seen at the top. The solitary old 1885 lighthouse was still in place on the east end of the West Breakwater (center of picture). At the bottom of the picture are the West Pier, lifesaving station (left), East Pier, and railroad yards. The alternating patches of open water and ice make an interesting design and show the effects of the prevailing winds that can pile ice and snow against the breakwaters and piers while the shipping channel may still be considered "open" to marine traffic. Researchers believe that Lake Erie has had more shipwrecks than any other Great Lake, with more than 1,700 documented. The lake's shallowness contributes to quick ice buildup, which has caught many ships unawares until it was too late to seek harbor. (CSU.)

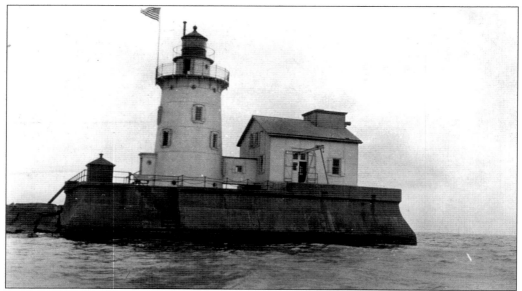

An American flag flew over the West Pierhead lighthouse on a regular basis while it was receiving daily attention from keepers to maintain its oil-fired lighting apparatus. An oil storage tank sits at the left of the lighthouse in this photograph, located outside of the lighthouse as a safety precaution due to the flammability of mineral oil, also known as kerosene. (CGHO.)

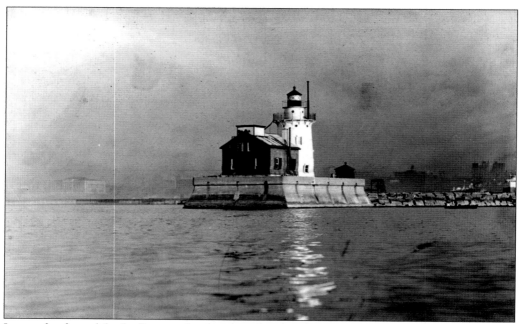

It was cloudy and foreboding on the day this photograph was taken, but since the shutters are open on the fog signal building, it was probably summer. A government report in 1916 listed Cleveland Breakwater as having had 1,224 hours of fog in 1915, compared to the location with the most hours of fog, Seguin, Maine, with 2,734 hours. (CGHO.)

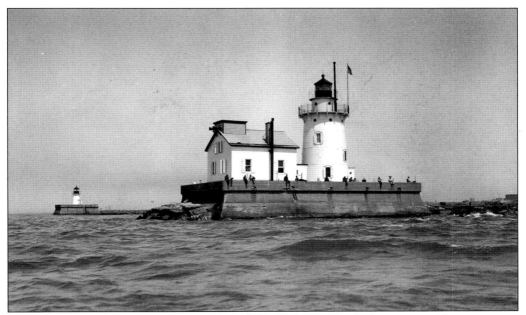

After the Coast Guard took over the U.S. Lighthouse Service in 1939, it was possible to put many men to work at the same time to do exterior maintenance on the West Pierhead lighthouse. This photograph shows at least 16 men on and around the lighthouse, which may have been the entire cadre of the Cleveland station. Railings were added to the lighthouse foundation, largely as a safety feature, although there are several reports of them having been broken by ships that hit the foundation. The railings were removable and were routinely taken down for winter. (CGHO.)

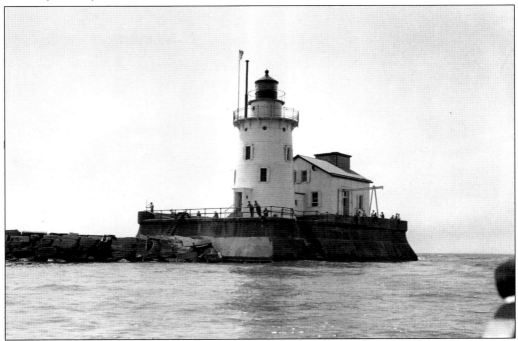

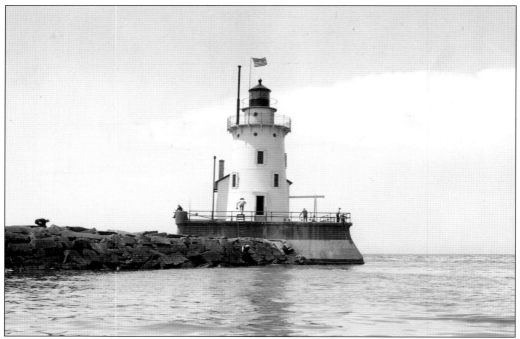

This classic "front door" view of the West Pierhead lighthouse shows the row of small round windows that were used as lookout positions. There was another level of lookouts in the watch room just below the lantern as well. One of the duties of the person on watch was to be sure that all the other harbor navigational aids were lit. (CGHO.)

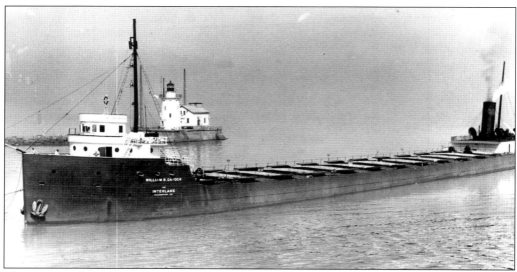

The West Pierhead lighthouse has witnessed a big change in the size of ships using the harbor. In this undated photograph, the 420-foot *William B. Davock* is entering the Cleveland harbor. The *William B. Davock* worked the Great Lakes from 1907 to November 11, 1940, when she sank in 210 feet of water in Lake Michigan, claiming the lives of all 32 men aboard. (CSU, photograph by Carl McDow.)

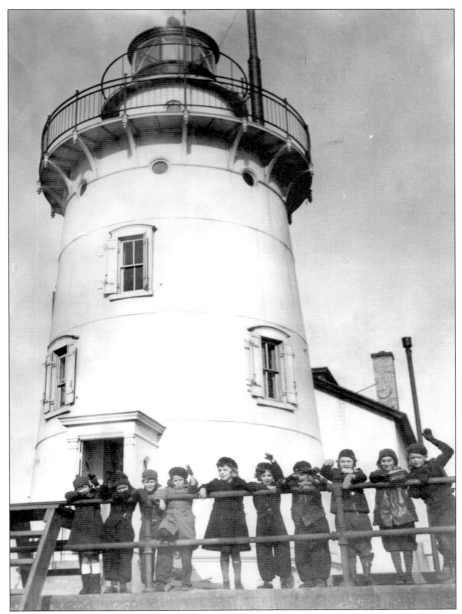

Through most of the 1930s, visitors were regularly allowed at the West Pierhead lighthouse. On November 19, 1934, a happy group from Park School, Cleveland Heights, toured the building and had a chance to discover how far it was from shore. The children pictured here (not in order) are Pamela Shannon, Michael McGenn, Marion Watt, Daniel Silver, Sanya Warshawsky, Oliver Deex, Eleanor Munro, Elaine Carnahan, Noel Pfiefer, and Buddy Jones. In August 1939, a *Cleveland Press* article described how visitors could observe National Lighthouse Week by making a trip to the lighthouse in a Coast Guard boat. Trips were available during daylight houses at either the lifesaving station on the West Pier or the Coast Guard district headquarters at the East Ninth Street Pier. During World War II, all Coast Guard facilities were placed off-limits to visitors, and a routine summer schedule of tours was never resumed. (CSU.)

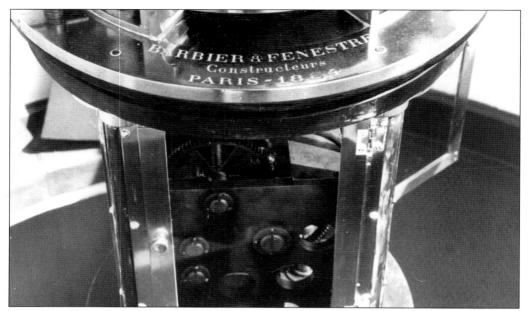

The Fresnel-type lens in the West Pierhead lighthouse was originally purchased for the 1885 lighthouse that preceded it. Built in Paris, France, in 1884, by the Barbier and Fenestre firm, the brass base contained ball bearings that rotated the heavy multifaceted lens. A metal weight system rotated the lamp to produce the characteristic red and white flashes of light assigned to Cleveland. (CSU.)

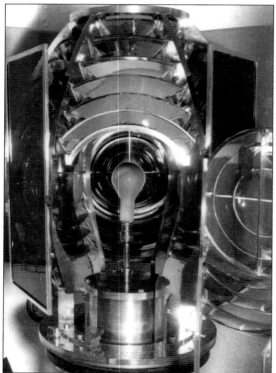

When electricity was installed in the West Pierhead lighthouse in 1931, a bulb sat squarely inside the hinged lens and produced 32,000 candlepower. This 1955 photograph shows the 50,000-candlepower replacement bulb that had been installed. In 1965, the light was automated and coastguardsmen no longer needed to stay in the lighthouse at night. (CSU, photograph by John Nash.)

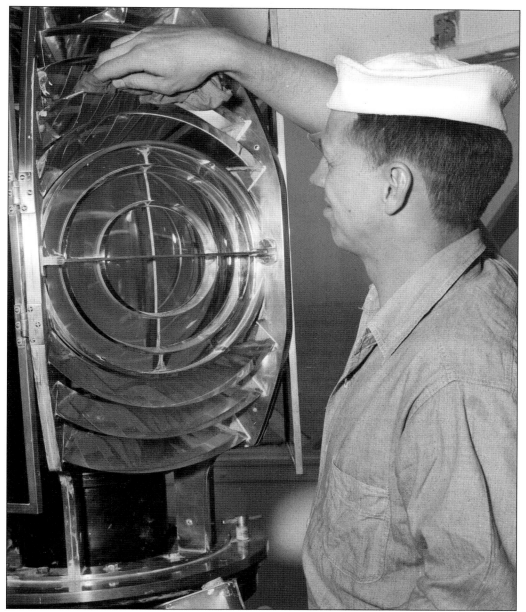

"Wickies" was the nickname for members of the Coast Guard who had the duty of polishing the Fresnel lens in a lighthouse. Norman G. Cunningham, engineman first class, is fulfilling that delicate duty in this undated photograph. In the days when the light was provided by a flame source, carbon buildup had to be removed daily. Regulations for lighthouse keepers contained detailed instructions on what cleaning materials to use. Even after lights were electrified, the elaborate lens needed constant attention to keep it dust- and smog-free in order to produce the brightest light possible. The lantern on the West Pierhead lighthouse originally had linen shades that were pulled over the windows during the day to protect the lens. By 1955, the Coast Guard was maintaining 48-hour watches at the West Pierhead lighthouse, with three people taking turns on six-hour shifts. (CGHO.)

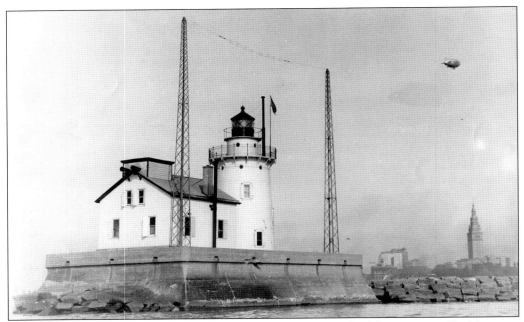

The 1911 lighthouse was, of course, intended to be a navigational aid for marine traffic. However, the pilot of the blimp in the sky at the upper right probably used the lighthouse as a check on his bearings as well. At one point, entrepreneurs had dreams of using Cleveland's Terminal Tower as a landing point for passenger service on blimps, but this never occurred. (CSU.)

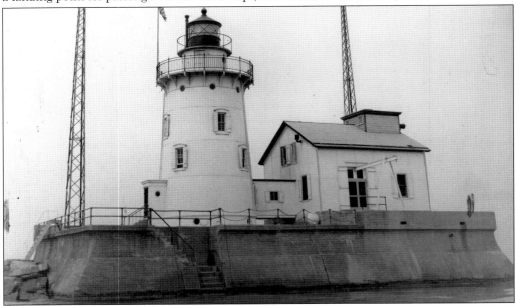

In 1936, a 50-watt radio beacon station was added to the West Pierhead lighthouse to provide extra navigational help to the larger ships seeking the Cleveland harbor. Despite this technological advancement, the time-honored flashing red and white light and the prominent white structure were still needed for the small boats that did not have such sophisticated equipment. (CSU, photograph by John Nash.)

Lighthouse personnel always had to be ready to deal with emergencies. Even after electricity was installed, these brass lanterns and some type of fuel oil were kept on hand at the West Pierhead lighthouse in case there was a power failure. The small utility lamps could be inserted in the lens to sustain the light's operation. (CSU.)

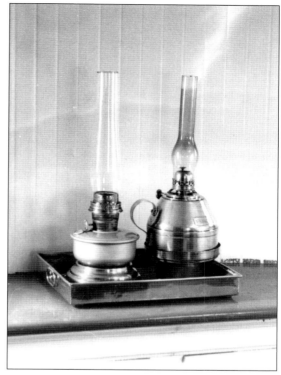

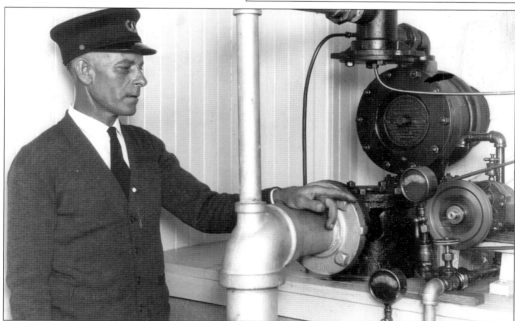

Keeper Charles E. Perry proudly demonstrates the West Pierhead foghorn equipment for a 1939 newspaper article that recognized National Lighthouse Week. He reported that he had climbed the 57 steps of the lighthouse at least 10 times every other day and had served as chief keeper at Cleveland for 29 years. Keepers had to be jacks-of-all-trades to maintain their positions. (CSU.)

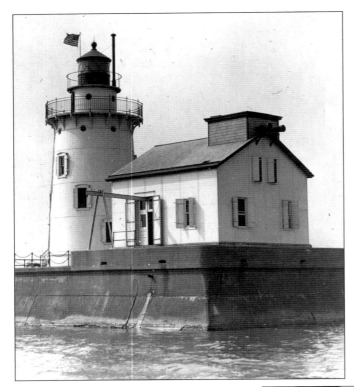

"Ooh-gah, ooh-gah, ooh-gah" was the incessant drone of "the Cow," Cleveland's much-maligned steam fog signal that emanated from the square building on the West Pierhead. The building contained two 28-horsepower oil engines operating a compressor and averaged 100 hours of work a month between April 1 and December 1 in the 1930s. (CGHO.)

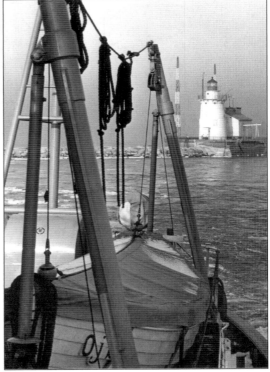

The USCG tug *Ojibwa* (foreground) had to make a quick trip to Cleveland from Erie, Pennsylvania, in late December 1960 to help check out a report that a bomb had been planted at the lighthouse. Several coastguardsmen had been placed in danger as a result of the hoax call. They had tried unsuccessfully to reach the pierhead by ice skiff and by climbing on the slippery rocks. (CSU.)

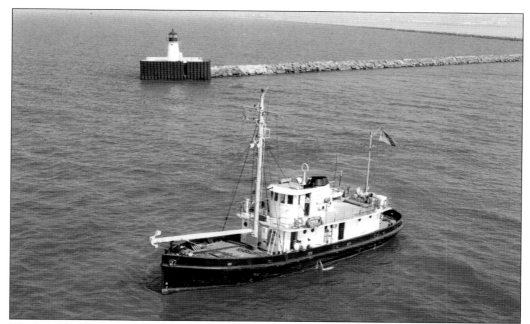

The USCG *Cherry* was an 86-foot tender that spent part of her Coast Guard career on Lake Erie, stationed at Buffalo, New York. She was built in 1932 by Leathem D. Smith Dock Company of Sturgeon Bay, Wisconsin, and remained in commission until 1964. An unknown photographer caught her passing the East Pierhead lighthouse in 1959. (CGHO.)

Not nearly as many pictures exist of the smaller Cleveland harbor lighthouse as of the larger one on the West Pierhead. However, an artful unknown photographer found the compact little lighthouse to be the perfect center point for this composition of seagulls and pier ropes, taken from one of the several marinas along the shore. (CSU.)

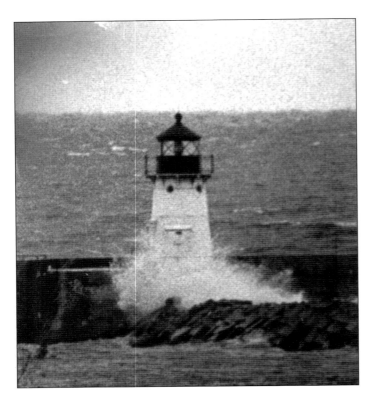

One almost feels wet and cold just looking at this photograph. Splashing waves frequently surround the West Pierhead (left) and East Pierhead lighthouses. Builders knew that those sites had to be able to withstand "heavy weather" and planned accordingly, but years of wave action take a toll. The foundation of the East Pierhead lighthouse was replaced in 2005; the West Pierhead foundation is scheduled for repairs in 2008–2009. (CSU.)

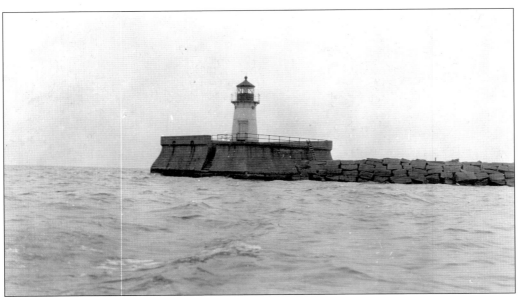

The East Pierhead lighthouse has always stood alone on its 40-foot-by-40-foot base. It has always been painted white and has a black lantern with a black roof. The East Pierhead lighthouse is 31 feet tall from its base to the center point of its lens. The light now has a flashing green characteristic but had a white light at an earlier point.

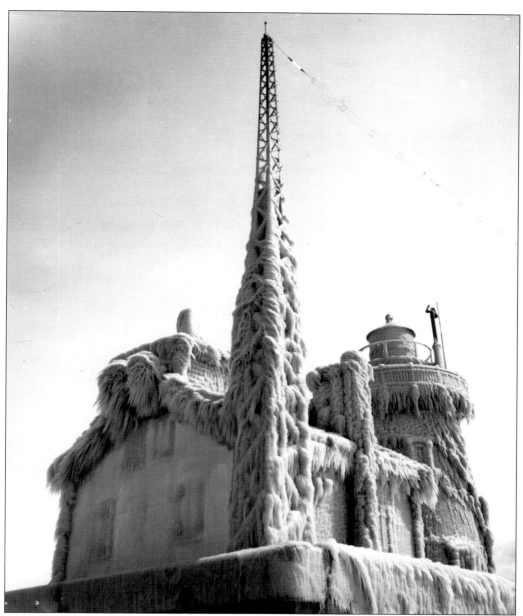

This photograph of the ice-encased Cleveland West Pierhead lighthouse is ample testimony to the ravages of winter on the Great Lakes. Usually such storms struck after the close of navigation and before the opening, but in some years surprise storms blasted ships in transit in November or even April. The lighthouse was stocked with food and had sleeping accommodations, just in case keepers were stranded there during storms. One particularly noteworthy storm occurred on March 16, 1911, just before the new lighthouses were lit for the first time. Eight men drowned in a storm that sent the fishing tug *Silver Spray* to the bottom of the lake, just off the East Breakwater. One of the men was swept off the tug *Effie B*. The men from the *Silver Spray* managed to swim to the breakwater but froze to death while waiting for aid. The gale was reported as "the worst that has visited the lake in years." (CGHO.)

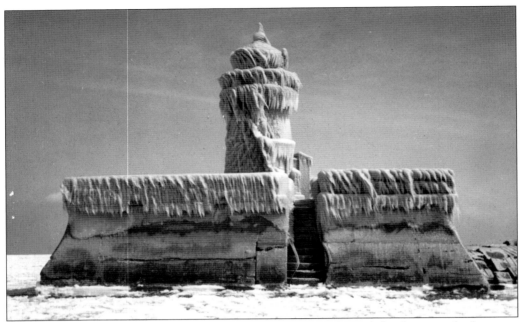

The cast-iron lighthouse on the East Pierhead has sometimes been defined as a spark plug–type structure. It looks more like a fireplug than a spark plug in its ice disguise. Even the concrete base took on an unusual appearance. This lighthouse was named to the National Register of Historic Places in December 1991 as No. 91001855. (CGHO.)

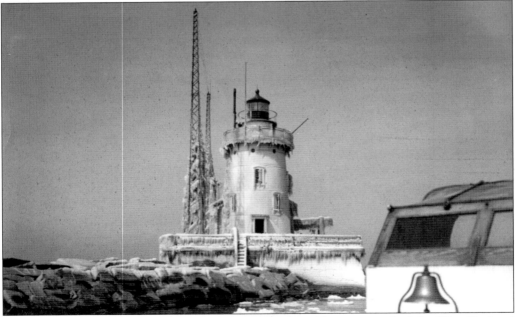

Lake Erie was only partially frozen when this Coast Guard boat approached the West Pierhead lighthouse to assess the conditions. In the winter, Lake Erie develops the most extensive ice cover of all the lakes. Its shallowness makes it more responsive to changing air temperatures. A normal winter can bring a 95 to 100 percent ice cover. (CGHO.)

No, it is not the North Pole; this is Cleveland on a wintry day. Even though the shipping season had ended, Coast Guard employees needed to check the West Pierhead lighthouse to see whether there was any ice damage to the radio towers and buildings. Thankfully, a minimal channel had been cut through the lake and the inspection trip was unimpeded. (CGHO.)

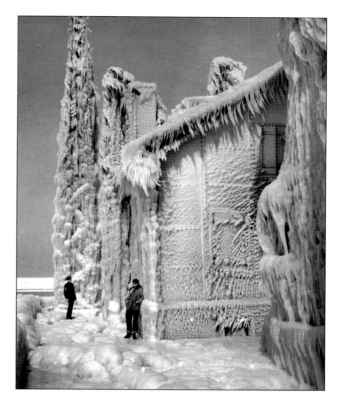

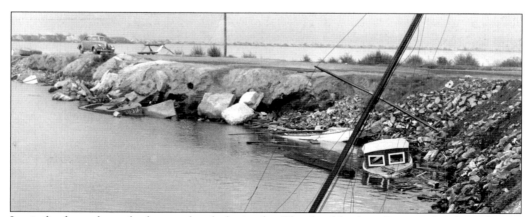

Ice is far from the only danger that lurks in the Cleveland harbor. Summer has hazards too. These pleasure boats were washed against a rocky breakwater near the Edgewater Yacht Club during a summer storm in the 1940s. Owners would have difficulty even identifying their craft after many had been reduced to piles of sticks. (CSU.)

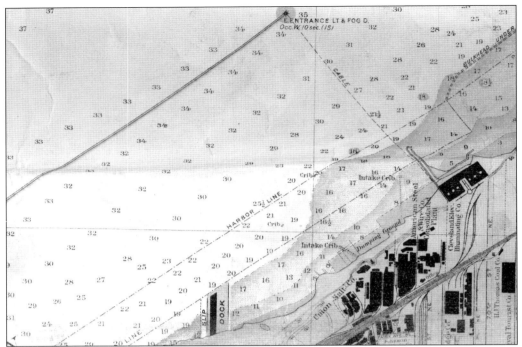

This 1930 Cleveland harbor map shows the location of the beacon light and secondary fog signal on the east end of the four-mile-long East Breakwater, referenced as East Entrance. These navigational aids were operated at first by acetylene-fired compressed air but soon were converted to electricity via a submarine cable from a power plant on shore. East Seventieth Street is at the right edge of the map. (CSU.)

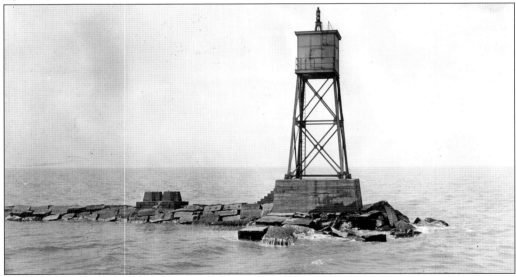

The small wooden boxlike room containing the East Entrance signal equipment, photographed in 1919, was a challenging place for keepers to work. They had to come by boat to this location, then climb the long ladder to the housing. One would certainly hope all the necessary tools were there ready to use. (CGHO.)

Lighthouse keepers needed to have no fear of heights, considering the job that these three men took on at the top of the secondary fog signal in March 1927. The megaphone on the left side of the boxy housing issued a fog warning. The keeper logbook from this time frame shows that a lot of time was spent working here on what was apparently troublesome equipment. (CSU.)

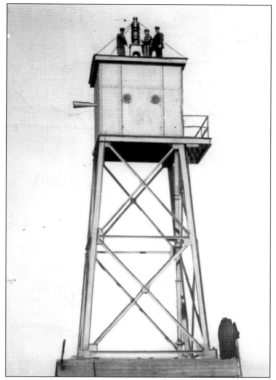

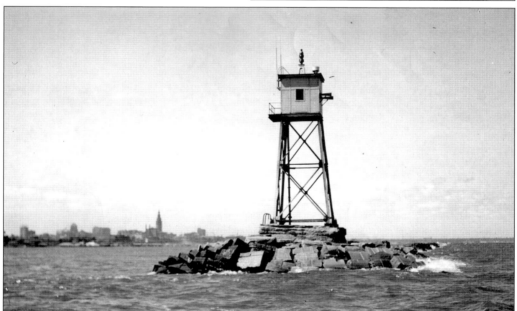

By 1949, the East Entrance fog signal had a stronger signal with two megaphones, not just one. It also carried a beacon light on top with a range of 8 to 10 miles. It was located offshore near East Seventieth Street. Since that area was then the city's Gordon Park, old references frequently cite this structure as the Gordon Park lighthouse. (CGHO.)

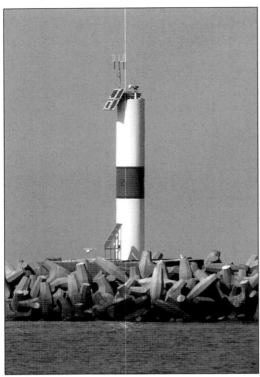

Today's navigational aid at the East Entrance to the Cleveland harbor has little resemblance to the ones that preceded it. It is a cylindrical tower, 47 feet tall, painted white with a wide red band across the middle. Like the pierhead lighthouses, it is solar powered. It is also only accessible by boat. (Photograph by Don Iannone.)

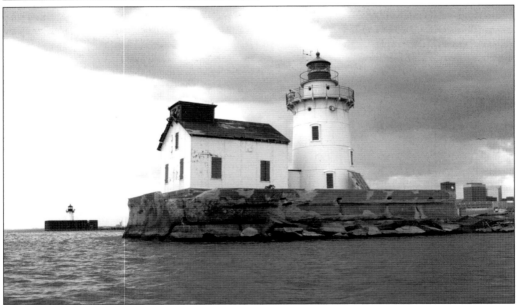

In 2008, anyone with a camera was capturing a possible "last look" at Cleveland's sister lighthouses. The fog signal building on the West Pierhead was scheduled for removal so that extensive repairs could be made to the pierhead itself. The East Pierhead lighthouse was put up for auction. Eventually the iconic towers will be replaced with simpler solar-powered ones. (Courtesy of Joseph T. Ruszala, Army Corps of Engineers.)

Five

SAVING LIVES AND PROPERTY

Cleveland's lighthouses have always been surrounded by other government agencies working to save lives, protect the harbors, and assist maritime commerce. The first such organization, the U.S. Revenue Cutter Service, had an active role on Lake Erie assuring that all ships entering the harbor paid customs duties. In 1874, the U.S. Life-Saving Service was established on the Great Lakes and a boathouse and residence for surfmen opened on the West Pier at the mouth of the Cuyahoga River two years later. (Before this time, volunteers came to the rescue of any ships that foundered in and around the harbor.)

The U.S. Life-Saving Service grew in importance as ship traffic through Cleveland's harbor increased. The treacherous nature of Lake Erie, due to its relative shallowness, led the lifesaving service employees on many dangerous trips. In 1897, a new facility for the lifesaving service was constructed to replace the original one.

In 1915, the U.S. government combined the U.S. Revenue Marine Service and the U.S. Life-Saving Service into a new organization, the Coast Guard, which continued to use the West Pier location. A distinctively modernistic complex of offices, boat docks, and workrooms was built on the West Pier in 1940 to house the Ninth District office of the U.S. Coast Guard, a command then stretching from the St. Lawrence River to Lake Superior. The L-shaped facility had a 60-foot lookout tower that many people erroneously assumed was a lighthouse.

The Coast Guard moored large cutters and other ships at the foot of East Ninth Street for years before moving its district headquarters there in 1974. Then the City of Cleveland Water Department used the West Pier/Whiskey Island facility for several years until the federal water regulations made it unusable without extensive replumbing.

In 2007, a group of community organizations created a reuse plan for the deteriorating facility that awaits a variety of funding streams to come to fruition. By 2008, pedestrian access to the West Pier was created, and the area began to have a new life as a fishing pier and lake viewing point.

A Wild Night on Lake Erie, Cleveland, Ohio.

This postcard of a "wild night on Lake Erie" is a reminder of the unpredictability of Lake Erie where serious storms can—and do—whip up with little notice. Accordingly, lighthouse keepers and lifesaving crews had to be vigilant for boats approaching the harbor that could be swamped by high waves, might crash against the rocky break wall, or meet another marine disaster. (Author's collection.)

Prior to the establishment of the U.S. Life-Saving Service in 1871, foundering ships and their crews depended on a Good Samaritan attitude of other ships in the vicinity. If trouble occurred near a harbor, men working in the area simply volunteered to go to the aid of a ship in trouble, knowing they might need a similar return service someday. (Author's collection.)

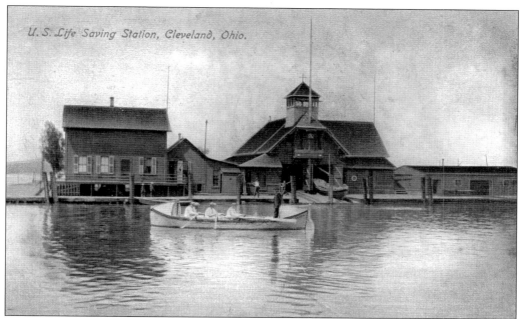

U.S. Life Saving Station, Cleveland, Ohio.

On September 20, 1876, soon after the United States government recognized the need for facilities on the Great Lakes to match those on the oceans, Cleveland acquired a lifeboat station. The postcard view above shows the boathouse with its lookout tower and the seasonal residence built for the captain of the station and his crew. Officers of the U.S. Revenue Cutter Service directed the new agency at first, under the aegis of the U.S. Department of the Treasury. Within a few years, the postcard below shows that trees had grown up on Whiskey Island behind the station, giving it a bucolic appearance that belied its crucial role in saving lives and property. By 1908, the station was described as "active from April to December" and was operated by a captain and nine men. (CSU.)

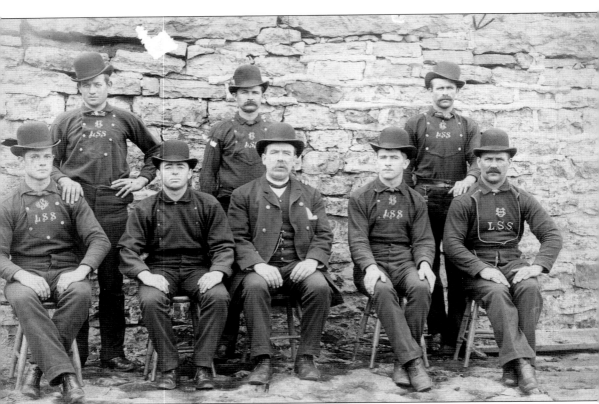

These dapper men were members of the U.S. Life-Saving Service at Cleveland when this photograph was taken about 1898. The identification of Eugene Butler (back row, right) was written with his own hand. Butler entered the service in Cleveland on April 22, 1897. The man seated in the center of the first row is undoubtedly Charles E. Motley, who was captain of the U.S. Life-Saving station from 1894 until 1907. Surfmen could be no older than 45, had to be physically fit, and were required to live at the station during the navigable season, normally April through December. Butler, like many others, worked first for the lifesaving service and then for the U.S. Lighthouse Service. He was appointed keeper of the Cleveland lighthouse on December 15, 1899, and served for about one year. His next service was as keeper of Rock Island Lighthouse in the Thousand Islands in the St. Lawrence River. He retired from the lighthouse service in 1912. (Courtesy of Butler's granddaughter Nancy A. [Butler] Trozze and Mark A. Wentling, Rock Island Lighthouse Historical and Memorial Association.)

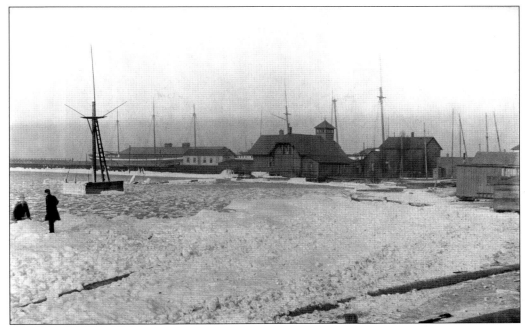

Early ice-ups in the Cleveland harbor added to the challenges of the U.S. Life-Saving Service headquartered on the West Pier. In this photograph from the late 1890s, the two men standing on ice in the harbor west of the lifeboat station must certainly have wondered how they would respond to any ships caught on the lake. (GLHS.)

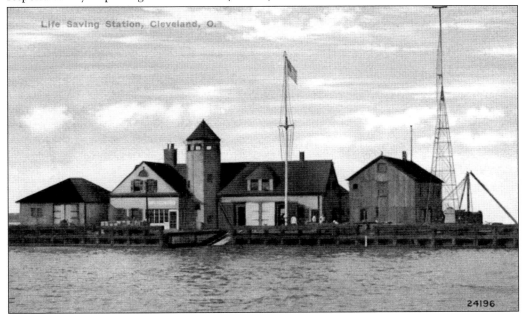

In 1897–1898, the shingle-style lifesaving station on the West Pier in the Cleveland harbor was replaced with a more compact station and improved boathouses. In the 1900 census, chief officer Charles Motley, his wife and children, a servant, and eight surfmen are listed as residents of the lifesaving station "on the Cuyahoga River." (CSU.)

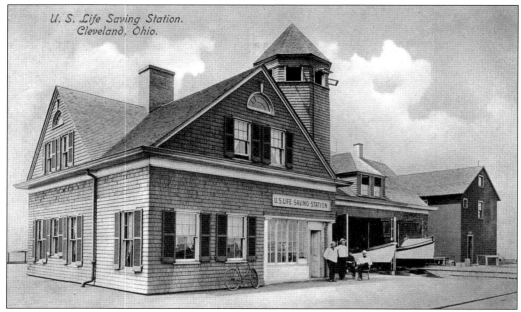

U. S. Life Saving Station.
Cleveland, Ohio.

This close-up view of the second lifesaving station, photographed just before 1915 when the U.S. Life-Saving Service became the U.S. Coast Guard, shows a cottagelike appearance, complete with shutters. The station has sometimes been described as "on Whiskey Island," which is a piece of land created by the rechanneling of the Cuyahoga River. It once housed distilleries and was a hideaway for smugglers during Prohibition. (CSU.)

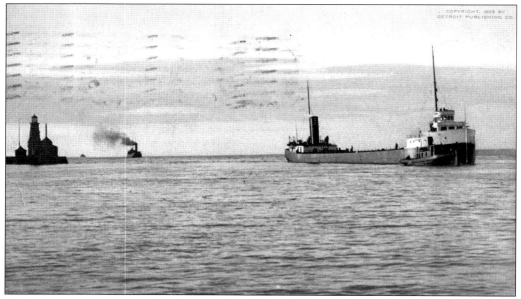

An ore steamer or two are headed into the Cleveland harbor in this 1908 postcard, past the West Breakwater lighthouse and bound for the Cuyahoga River channel. At this time, the Pennsylvania Railroad ore docks at Whiskey Island were considered the fastest unloading plant anywhere and helped Cleveland achieve the reputation of "the largest ore market in the world." (CSU.)

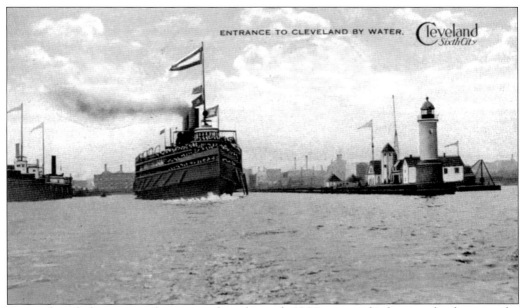

An unidentified passenger ship pictured on this early-1900s postcard is leaving the depot on the Cuyahoga River and heading into Lake Erie. During the time that steamers docked on the river, many people would have noted the buildings of U.S. Life-Saving station No. 239 on the West Pier as they went by. (CSU.)

This undated penny postcard shows a tug assisting a laker into the Cuyahoga River, past the lifesaving station on the West Pier. This view makes the harbor channel look somewhat wider than it really is. The distance between the East and West Piers is only 200 feet, unchanged for nearly 150 years. (Author's collection.)

Many postcards in the Walter Leedy Collection at Cleveland State University feature nighttime nautical scenes. In the one above, a light shines brightly from the 1875 wooden beacon that was on the West Pier in the Cleveland harbor for many years, but the captain of the passenger steamer behind the beacon was undoubtedly grateful for some assistance from moonlight that night. The night scene below represents a later period as it shows both the pyramidal East Pier beacon and the conical West Pier beacon light that was used from the early 1900s until 1917. Passenger ships often departed Cleveland at night as that made it possible to arrive in either Detroit, Michigan, or Buffalo, New York, early the next morning. (CSU.)

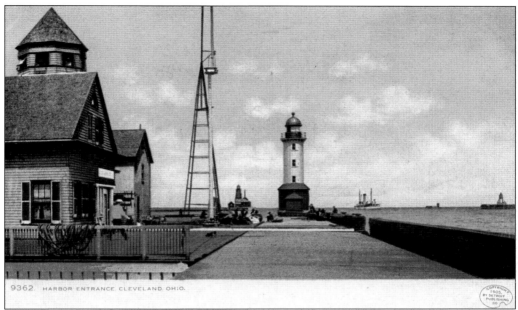

The 1897 postcard view above shows a glimpse of the 1885 lighthouse on the West Breakwater in the distance between the radio tower and the conical West Pier beacon No. 2. In the days before telephones were installed, the lighthouse keepers and the lifesaving crew depended on signal lights and flags to let each other know that some marine problem had been sighted. The postcard below, an earlier view of the same scene taken at a greater distance along the pier, is a reminder that the lifesaving service employees either walked or took a boat to get to the headquarters. The clapboard siding on the lifesaving station was sometimes shown on color postcards as beige and on others as white, but no official descriptions could be found to confirm its colors over time. (CSU.)

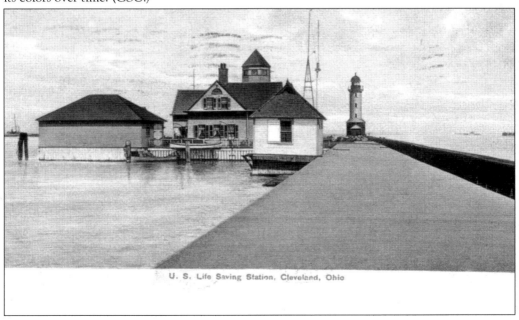

U. S. Life Saving Station, Cleveland, Ohio

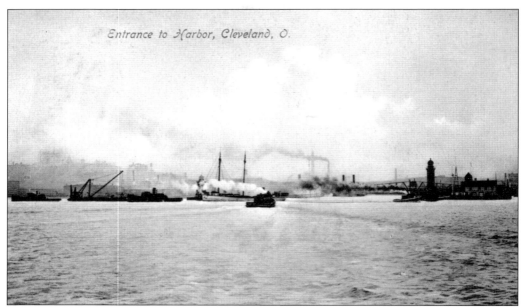

Entrance to Harbor, Cleveland, O.

Above, many vessels are bustling through the Cleveland harbor in this postcard scene—sailboats, a tugboat, a passenger steamer, and others. Lost in the mix are the two beacon lights, the cylindrical one on the West Pier (at right) and the wood pyramidal one on the East Pier. In 1899, Great Lakes historian J. B. Mansfield wrote that Cleveland had been "the greatest shipbuilding center on this continent" for 10 years. The 1912 postcard below shows the U.S. Life-Saving station (at left) with its grouping of buildings for operations, equipment, and storage. The then-new East Breakwater Pierhead lighthouse is visible in the distance just behind the ship. The sturdy wooden beacon on the East Pier (at right) was still in use when this postcard was created. (CSU.)

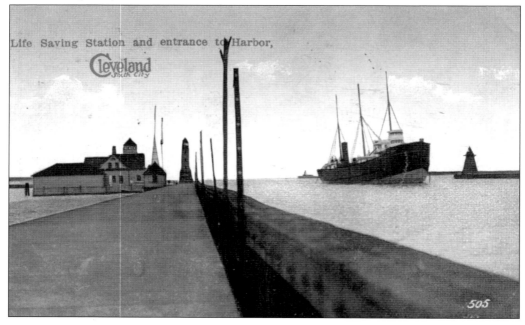

Life Saving Station and entrance to Harbor, Cleveland

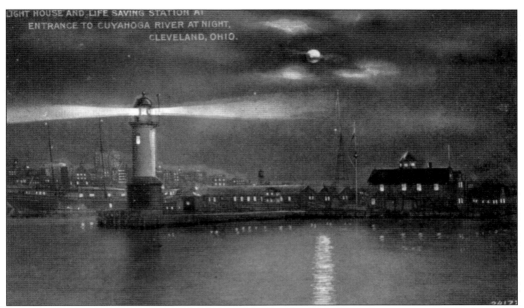

LIGHT HOUSE AND LIFE SAVING STATION AT
ENTRANCE TO CUYAHOGA RIVER AT NIGHT,
CLEVELAND, OHIO.

Two postcards from the early 1900s provide a reminder that the lifesaving service was on duty around the clock, seven days a week, during navigation season. In the day view, ships are docked in the channel near the station. In the night view, there are lit windows all over Cleveland, not just in the crew quarters on the West Pier. The beacon light in the round structure displayed a fixed white light from a sixth-order lens. It was familiarly referenced as a lighthouse, even though there was a much larger lighthouse on the east end of the West Breakwater at this time that had a revolving beam visible about 16 miles. (Above, CSU; below, author's collection.)

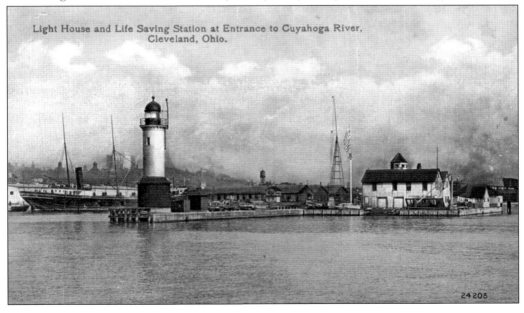

Light House and Life Saving Station at Entrance to Cuyahoga River, Cleveland, Ohio.

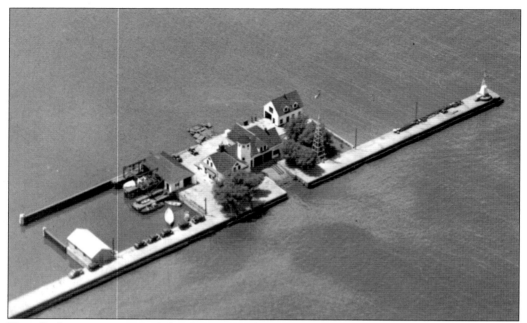

Trees had grown up around the Coast Guard station by the time this aerial photograph was taken in the 1930s. By this date, the West Pier beacon had been replaced with a skeleton tower light. Employees could drive cars to the station by a circuitous route, but the rest of their work would be handled by boat. (CSU.)

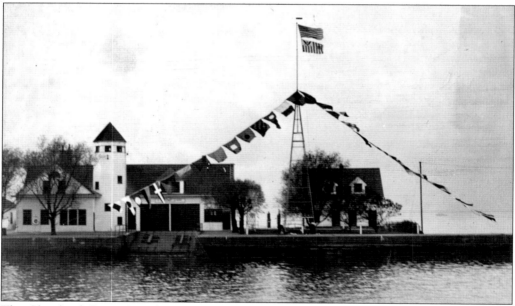

The Cleveland Coast Guard station looks especially festive on Navy Day, October 27, 1935. Navy Day celebrations began in 1922 and marked the birthday of former assistant secretary of the U.S. Navy Theodore Roosevelt, who later became president of the United States. In the 1970s, the date for this event moved to October 13, the date the Continental navy was founded in 1775. (CSU.)

The "old" Coast Guard station on the West Pier was being dismantled when Fred Bottomer of the *Cleveland Press* took this picture in June 1940. The station had served its purpose for over 40 years, but it could no longer accommodate the increased activities to be managed once the U.S. Lighthouse Service was added to the Coast Guard in 1939. This merger resulted in the Coast Guard taking on responsibility for all radio beacons, fog signals, buoys, and lighthouses along the nation's 40,000 miles of coastline, including major waterways such as the Ohio and Mississippi Rivers. In addition to its duties of saving lives and protecting marine property within its assigned districts, the Coast Guard also had mobile units that could be rushed into flood districts anywhere in the country. The Cleveland division performed efficient service in the Ohio Valley flood in 1937. (CSU.)

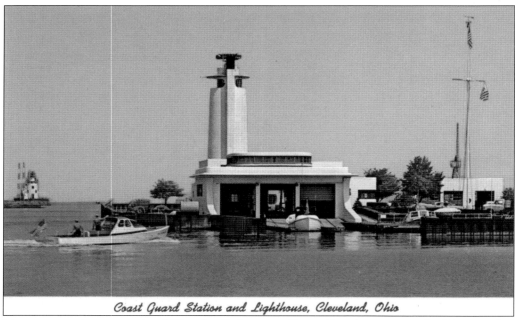

Coast Guard Station and Lighthouse, Cleveland, Ohio

Many postcards were made of Cleveland's fine new Coast Guard station in the 34 years that it occupied the West Pier of the harbor. Contrary to popular thought, its 60-foot tower was a lookout point, not a lighthouse. Writers frequently referenced it as the Coast Guard lighthouse even though the official lighthouses were standing firmly in the Cleveland harbor about a mile away. The station received many accolades for its distinctive architecture and was a dramatic presence in the harbor. It has been said that its architect, J. Milton Dyer of Cleveland, designed the building's round corners to resist wind. Cleveland historian William Ganson Rose called it "the nation's most beautiful USCG station erected on made land," which called attention to the fact that it was primarily built on a pier and fill from harbor dredging. (CSU.)

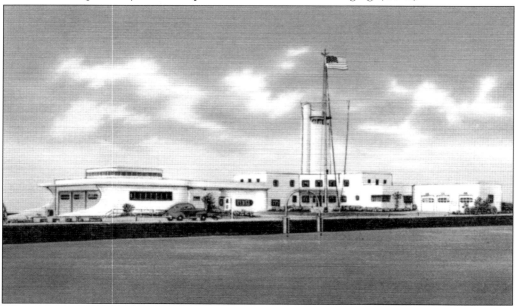

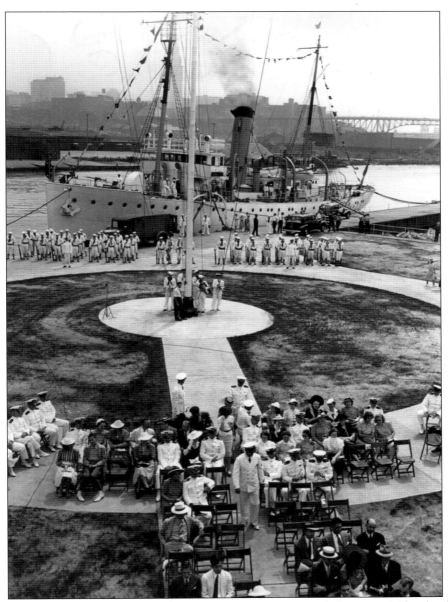

Many dignitaries were present on August 10, 1940, for the public dedication of Cleveland's new Coast Guard station. Rear Adm. Russell R. Waesche, commandant of the U.S. Coast Guard, gave the dedication address, which was broadcast over a national radio network. The event was coordinated with the observance of the 150th anniversary of the creation of the U.S. Revenue Marine Service, the nation's first armed sea force. The Coast Guard was formally organized in 1915 from a merger of the U.S. Life-Saving Service and the U.S. Revenue Marine Service. In 1939, the U.S. Lighthouse Service was incorporated into the Coast Guard as well. The Coast Guard commandant had special praise for the Cleveland unit, which had performed efficient service in the Ohio Valley flood in 1937. The organization was temporarily moved into the Department of the Navy during World War I, and members served overseas as well as around the United States in protecting navigable waters. (CSU.)

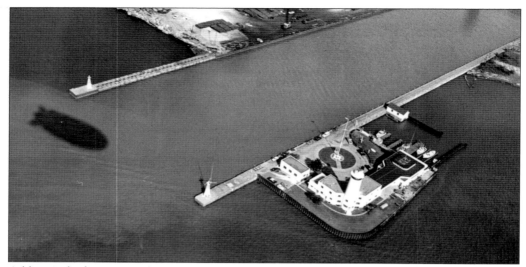

A blimp's shadow graces this aerial photograph of the U.S. Coast Guard station on Cleveland's West Pier, but that craft was not part of the Coast Guard fleet. There are several kinds of small boats at the ready next the station. The Coast Guard used a dock on East Ninth Street for large craft and moved the headquarters to that location in 1975. (CSU.)

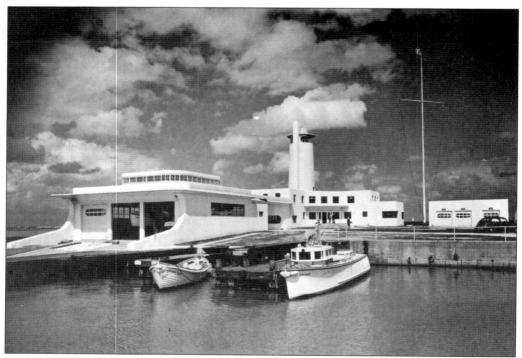

The entire Coast Guard station looks somewhat like a car ferry in this 1948 photograph taken from the boat dock end. This is not coincidental, as the architect did have ships in mind when he designed the station. Users reported that the small passageways throughout the building were somewhat like below the decks of a ship. (CSU.)

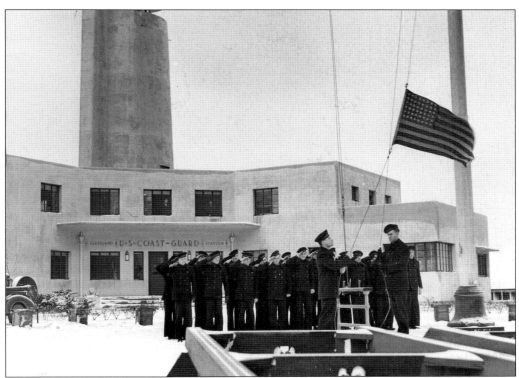

Cleveland's Coast Guard station made a dramatic background for many special events through the years. The 1943 flag-raising ceremony pictured above took place during the time that the nation was at war. The Coast Guard was among the American forces that attacked and seized Japanese strongholds in the Solomon Islands and worked as defense forces in Greenland, Iceland, and Alaska Territory. In the October 1962 photograph at right, new station commander master chief boatswain's mate Donald W. Pyle (right) is being welcomed to Cleveland by former commander chief boatswain's mate Theodore J. Polgar (left). Polgar became commander of the Ashtabula, Ohio, station. (Above, CSU, photograph by Walter Kneal; right, CSU, photograph by Frank Aleksandrowicz.)

Formed in 1942, the women's reserve of the U.S. Coast Guard was named SPARS, using the initial letters of Coast Guard mottoes—*Semper paratus* and Always Ready. SPARS took on many of the shoreside jobs, freeing men for marine duties including overseas service. Radiomen third class Alba Clark (left) and Cecilia Witoslowski served at the Cleveland Coast Guard station in November 1943. (CSU, photograph by Walter Kneal.)

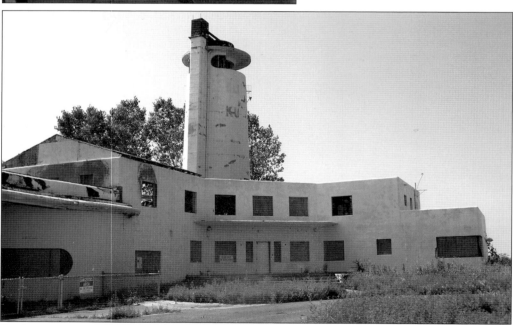

By the summer of 2008, the abandoned Coast Guard station had taken on a forlorn air, with roof pieces missing, graffiti on its walls, and tall weeds covering the walkways. Yet, posted on one of the buildings was information about three newly proposed plans for its redevelopment and public use. (Photograph by Nathan Supinski.)

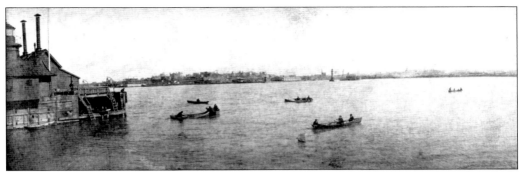

Drill and practice was a regular part of a surfman's six-day workweek as a member of the U.S. Life-Saving Service. In the photograph above, several men are seen behind the 1885 West Pierhead lighthouse in their various boats. One group even has a small sailboat in the water beside them. In the April 1912 photograph below, the Cleveland crew has just hit the water in a contest to see how fast a boat could be launched. The public was often invited to demonstrations of boat-handling skills. (Above, GLHS; below, CSU, photograph by L. Van Oyen.)

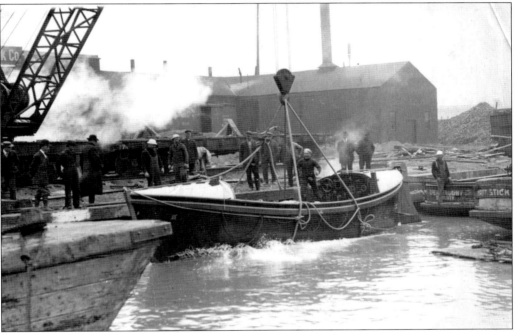

An informal motto of the lifesaving service was "You have to go out but you don't have to come back." Employees of the U.S. Life-Saving Service in Cleveland received numerous commendations for their bravery. Capt. Hans J. Hansen and his crew (shown here in April 1919) were early responders in the 1916 disaster when there was a natural gas explosion in a waterworks tunnel in the Cleveland harbor. (CSU.)

The Lyle gun, a cannonlike firearm, was a standard piece of equipment at lifesaving stations for many years. In this 1919 photograph, members of the Cleveland lifesaving station crew are shown next a beach cart, preparing to use the Lyle gun to shoot a line from shore to ship. The line could then be used to transport people to shore in a breeches buoy. (CSU.)

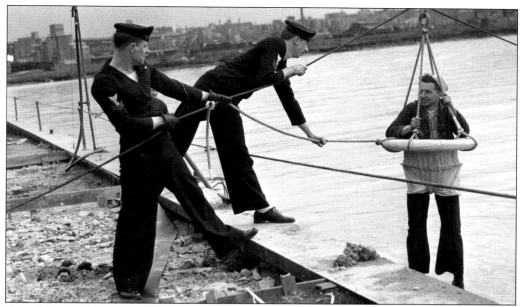

Crowds turned out regularly for exhibits of lifesaving equipment provided by the Coast Guard, usually in conjunction with observances of the organization's founding. Surfman Curtis A. Frazier was taken off the cutter *Tahoma* at the East Ninth Street dock for this 1939 demonstration. The officer in charge said that a crew of 50 men could have been retrieved this way in 20 minutes. (CSU.)

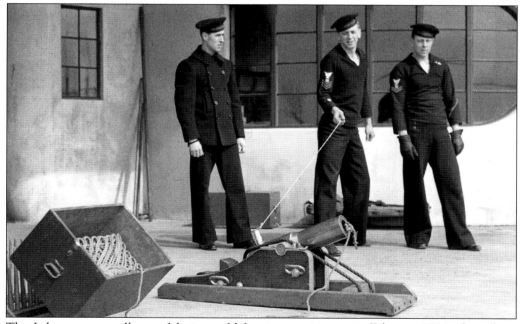

The Lyle gun was still a useful piece of lifesaving equipment in February 1944 when these coastguardsmen practiced its use. Using an 18-pound projectile, they could fire a shot line nearly 700 yards to a vessel in distress, when no other option was available for rescue of the crew. (CSU, photograph by Walter Kneal.)

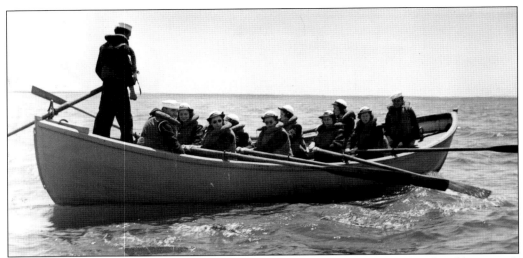

Women who joined the Coast Guard's SPARS during World War II had to be able to work with boats. This group is practicing its oar-handling skills on Lake Erie in June 1943 with three coastguardsmen at the ready. It is hard to know how anyone kept their hats on their heads even on the calmest of days. (CSU.)

Any day can hold a surprise mission for members of the Coast Guard. Two unnamed coastguardsmen had the difficult task of searching for a suicide victim off the East Ninth Street Pier in June 1957. For years, this location was even called "Suicide Pier" because many repeatedly selected it for a leap to death. (CSU.)

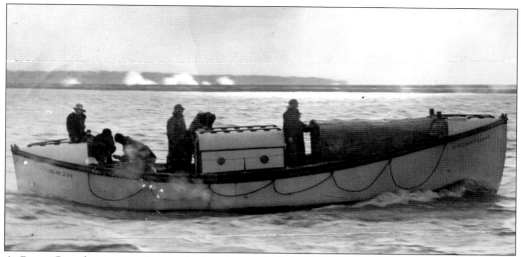

A Coast Guard crew speeds past the breakwater lighthouses in a powerboat in this March 1923 photograph. Powerboats came into use for the lifesaving service in 1905 and made big changes in the work of the service as it could now respond to emergencies at a greater distance from the station. (CSU.)

A side paddle wheel steamer named *Fessenden* served twice as a U.S. revenue cutter, first in 1865 and again in 1883 after receiving a new iron hull. She was 192 feet long and one of the best-known cutters to serve on the Great Lakes. She was named after Pres. Abraham Lincoln's secretary of the treasury William P. Fessenden. The U.S. Revenue Cutter Service became the Coast Guard in 1915. (CGHO.)

Blinded in a blizzard that lashed Lake Erie in November 1929, pilots of a rum boat crashed into a seawall near Cleveland, wrecking the craft. Citizens and coastguardsmen saved two men in spectacular rescues. Fifty cases of Canadian whiskey were found in the cabin cruiser. The men, who said they had been fishing, were released, since no one had seen them in the boat. (CSU.)

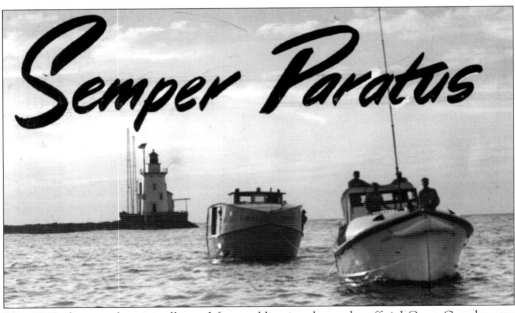

This 1949 photograph, originally used for a publication, bears the official Coast Guard motto *Semper paratus*, which is translated to "always ready." In the picture, a Coast Guard surfboat is towing the fishing boat *Robert* to her dock in Cleveland after the *Robert*'s motor failed and left her adrift 10 miles from shore. The Cleveland West Pierhead lighthouse is shown in the background. (CSU.)

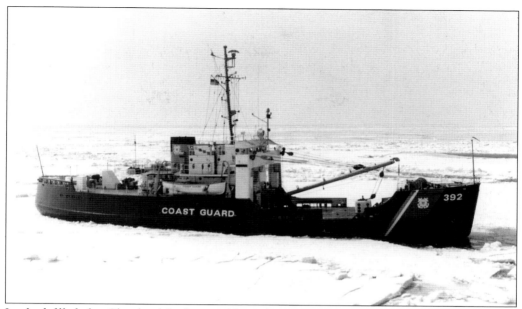

Ice had filled the Cleveland harbor on November 25, 1972, when the 180-foot buoy tender *Bramble* came from Detroit to work as an icebreaker in the area. Built in 1944, the *Bramble* had a distinguished record of service before transferring to Great Lakes service in 1962. She was decommissioned in 2003 and is now a museum ship at Port Huron, Michigan. (CSU.)

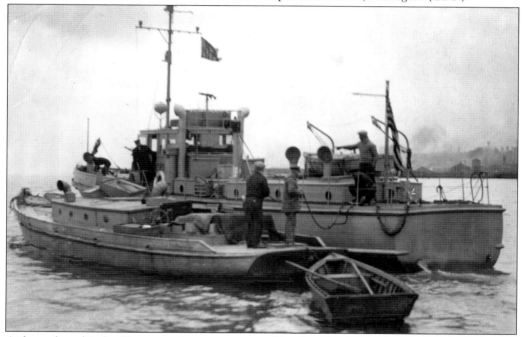

At least three kinds of boats rendezvous in an icy Cleveland harbor in this photograph. In 1948, a *Cleveland Press* article reported that the Cleveland Coast Guard station had one 63-foot boat, a 33-foot picket boat, a 36-foot self-bailing nonsinkable boat, a 30-foot rescue boat for close-in operations, a 25-foot speedboat, two 25-foot surfboats, and two 16-foot skiffs. (CSU.)

The Coast Guard placed a fireboat in commission in the Cleveland harbor in October 1942 to protect war installations from fire. It had a close liaison with the city fire department, which did not own fireboats at that time. In 1945, most of the coastguardsmen attached to the fireboats were combat veterans recently returned from overseas service. (CSU.)

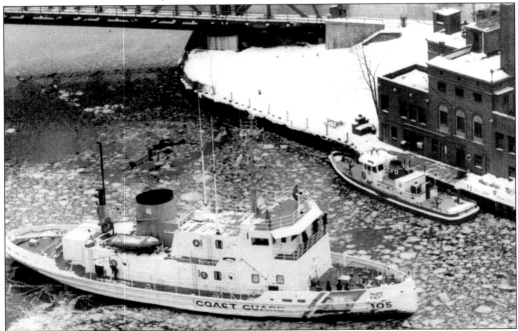

Even a fireboat can need help now and then. In this photograph taken on January 13, 1981, the U.S. Coast Guard cutter No. 105 is assisting the City of Cleveland's fireboat, the *Anthony J. Celebrezze*, on the Cuyahoga River. Named for a longtime Cleveland mayor, the fireboat became famous in its own right when it helped quell the notorious Cuyahoga River fire in 1969. (CSU, photograph by Van Dillard.)

Six

SHARING THE HARBOR

Over the years, vessels of every description—from expensive racing yachts to homemade milk-carton boats—have plied the river and lake waters at the Cleveland harbor. The earliest settlers of Cleveland took immediate advantage of the location to begin shipbuilding at the harbor. As soon as the Erie Canal opened in 1825, passenger vessels began traveling across Lake Erie, contributing to the peopling of the nation's midwestern regions. Canals in Ohio, Indiana, and Illinois allowed products of the interior United States to reach the lake and be transported everywhere. By 1913, four out of every five steamships carrying iron ore and coal on the Great Lakes were operated from Cleveland. Commercial shipping interests continue to dominate activities at the Cleveland harbor today.

Lake Erie has provided many opportunities for playtime too. Steam passenger service became very big business in the late 1800s and into the early 20th century, giving thousands of people a glimpse of the lighthouses as they sailed by. Amusement parks and summer colonies sprang up on the shorelines to entice citizens to take a trip on the lake.

Industrialists making fortunes in Cleveland took up yachting as a leisure-time activity with fervor and formed yacht clubs, several of which still line the Lake Erie shore at Cleveland. The public was welcomed at city parks with bathing beaches and canoeing facilities. A state park and marina opened in 1978 adjacent to Gordon Park. Cleveland is still one of those cities where one can fish for pleasure, from shore or in a boat.

Clevelanders, Ohioans, and visitors from everywhere have taken up water-based leisure pursuits. In 2007, there were 748 recreational boats registered just in Cuyahoga County.

In addition to all the watercraft in the harbor, there is a bright orange object that is often mistaken for a freighter until viewers realize it is sitting still. Known simply as the crib, this 100-foot steel and concrete structure sits over intake tunnels that bring Lake Erie water to shore for processing and distributing to the region's residents.

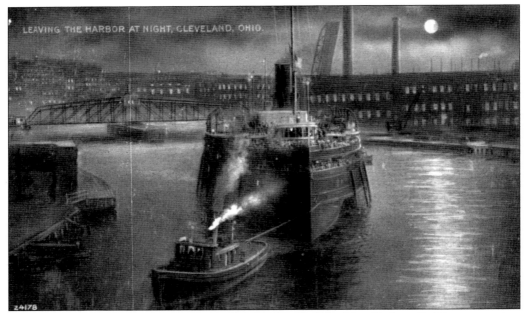

In the early 1900s, a pleasure trip from Cleveland to Buffalo, New York, called for an evening departure, so it was quite possible for the eastbound steamer to meet a westbound steamer along the way across Lake Erie. In a congressional hearing in 1914, one steamship owner reported that steamers met "every 11 minutes" while crossing Lake Erie. (Author's collection.)

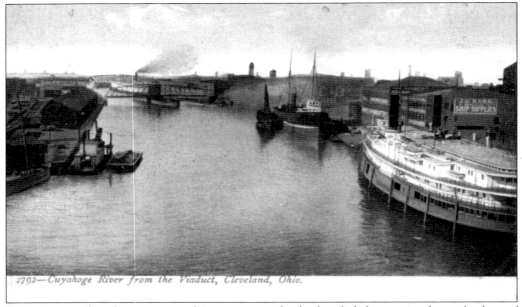

Everyone traveling by passenger ship went past the harbor lighthouses in the early days of scheduled ferry service. The ships took on passengers at the foot of West St. Clair Street on the east side of the Cuyahoga River, as shown in this postcard from the early 1900s. An unnamed side-wheel steamer rests at the dock. (Author's collection.)

The steamer *Eastland* visited Cleveland regularly between 1907 and 1915, providing day excursions to Cedar Point amusement park. She was then sold to another firm for service on Lake Michigan, and on July 24, 1915, she rolled over while tied to a dock in the Chicago River, killing 845 passengers and crew. Amazingly, she was raised from the river and used as a training ship during both World War I and World War II. (Author's collection.)

In the heyday of excursion steamers on Lake Erie, it was common to see crowds pouring from a boat to spend the day or weekend enjoying themselves in Cleveland. In this 1912 photograph, the Detroit boat has just arrived at the docks, sending its passengers up the steep hill on West St. Clair Street. (CSU.)

Steamer "City of Cleveland," D. & C. Line, Detroit, Mich.

The author's grandfather and his second wife were among the thousands of couples during the 1920s who took wedding trips on the *City of Cleveland*. The Detroit and Cleveland Navigation Company (D&C) owned the coal-fired steamship, built in 1907. She had a long sailing history until disabled in 1950 in a collision off Harbor Beach, Michigan. (Author's collection.)

Imagine how exciting it must have been for a 12-year-old farm boy in Kansas (the author's father) to receive this postcard picturing the *City of Cleveland* and describing the ship's features. Harvey Bates's father and new stepmother were passengers in September 1921 on their way across Lake Erie from Michigan to New York to see Niagara Falls. (Author's collection.)

In 1913, a landing pier was built at the foot of East Ninth Street in Cleveland especially for the two passenger steamer lines that served Cleveland. Commercial traffic on the Cuyahoga River forced the need for separate facilities that could provide spacious depots to handle the crowds that assembled to board ships. The postcard above says that "the magnificent passenger steamers of the C. & B. Transit Co. and the D. & C. Navigation Co." operated from the "most modern and largest passenger and freight terminal on the Great Lakes." The pier itself was 700 feet long; the terminal area covered five and one-half acres. The 1932 postcard below shows a passenger ship at one dock and a steam train on the tracks between the depots. (Author's collection.)

306:—East 9th Street Pier showing Skyline at Night, Cleveland, Ohio.

Largest and most costly passenger steamer on inland waters of the world. Actual dimensions - length, 500 feet; breadth 98 feet 6 inches; 510 staterooms and parlors accommodating 1500 passengers

The Cleveland and Buffalo Transit Company's *Seeandbee* provided daily service between Cleveland and Buffalo, New York, beginning in 1913. She was a highly popular moneymaker for her owners until the onset of the Depression made pleasure trips impossible for many people. She was 500 feet long and had elegant staterooms, dining parlors, and a grand ballroom. Purchased by the U.S. Navy in 1942, she was renamed the SS *Wolverine* and served out her life as a training ship. In the October 1927 photograph below, the *Seeandbee* (with her distinctive four smokestacks) is docked at the East Ninth Street Pier along with the D&C line's *City of Ignace*. The East Ninth Street Pier in Cleveland may have been the busiest place in Cleveland when several ships were docked there at once. (Above, author's collection; below, CSU.)

This postcard view of the great ship *Seeandbee* at dock at Cleveland's East Ninth Street terminal shows landscaped grounds and parking space for a few automobiles. The *Seeandbee*, a coal-burning, paddle-wheeled ship, could carry 1,500 passengers. She created memories for many people in her time, including sailors in World War II. Memorabilia and scale models of the *Seeandbee* are still available for sale at online auction sites. (Author's collection.)

The side-wheel steamer *City of Buffalo* was a frequent visitor to Cleveland in the great era of passenger ships. Another Cleveland and Buffalo vessel, it was advertised as the "largest, finest and fastest" steamer of its class in the world. Such ships also carried some commercial freight in their daily runs between Cleveland and Buffalo, New York. (Author's collection.)

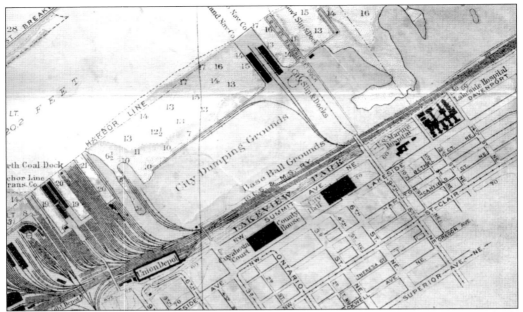

The East Ninth Street Pier became a hub of activity once the passenger ship piers were built there and connected to railroad service. Near the piers at the upper right is an area marked "Gov't Slip & Dock" that would be turned into the Ninth District Coast Guard headquarters in 1975. Also noticeable on the map are the U.S. Marine Hospital (demolished) and Cleveland Union Station (demolished). (CSU.)

YACHT RACE.

What is so fine on a summer day as catching a breeze and sailing across Lake Erie? In the 19th century, yachting became as popular a sport in Cleveland as it was along the Atlantic Coast. Several boat clubs were organized to build common facilities and operate competitive events. (Author's collection.)

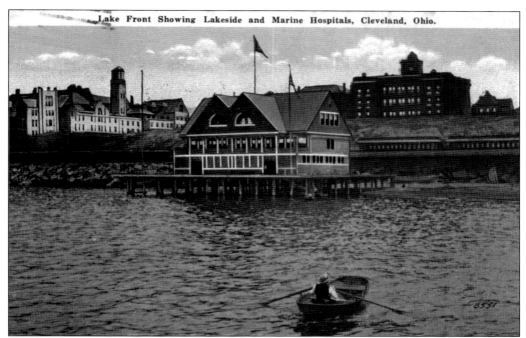

The Cleveland Yacht Club (CYC) was organized in 1878, operating first from a dock on the Cuyahoga River. The club dedicated its distinctive double-gable clubhouse (foreground above) on Lake Erie at the foot of East Ninth Street in 1895. (The U.S. Marine Hospital is also shown on the bluff above the clubhouse.) In 1914, the CYC clubhouse was towed by barge to the Rocky River lagoon (below) where many members routinely kept their boats during the summer months. The popularity of sailing on Lake Erie has never waned, even as motorized boats and Jet Skis have become common sights in the harbor. (CSU.)

Cleveland Yacht Club, Lakewood, Ohio.

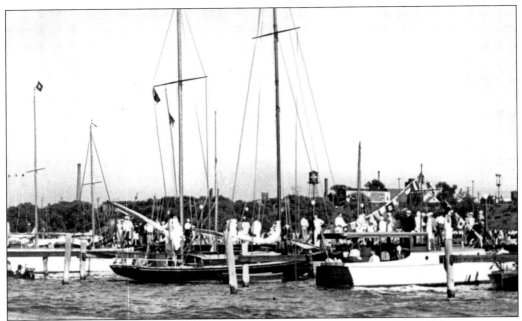

One of the biggest events for Cleveland-area sailors in the early part of the 20th century was the Cleveland Day Regatta, celebrating the city of Cleveland's birthday. This *Cleveland Press* photograph taken on July 26, 1932, shows many kinds of crafts being readied for a parade along the Lake Erie shore. (CSU.)

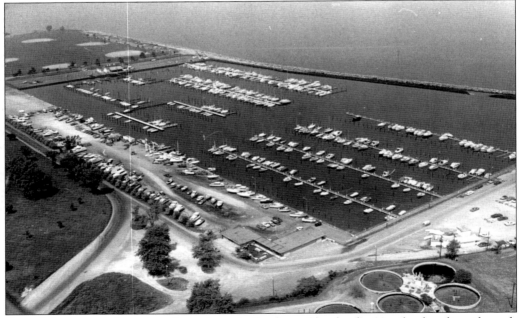

Several lagoons and marinas have been built along Cleveland's 14-mile shoreline through the years. The Edgewater Yacht Club had settled comfortably into its clubhouse and docks at 6700 Memorial Shoreway by the time this photograph was taken in 1971. The circular structures at the lower right are part of the Westerly Wastewater Treatment Plant. (CSU.)

The 524-foot-long laker *William D. Crawford* is shown here in the Cleveland harbor in January 1940, assisted by the tug *Oklahoma* of the Great Lake Towing Company. (The term *laker* is slang for a vessel that spends all its time on one of the five Great Lakes.) She was built by the American Shipbuilding Company of Lorain in 1914. Renamed the *George Hindman III*, she was scrapped in 1969. The photograph also shows the new Coast Guard station that was under construction on the West Pier, immediately behind the 1898 station it was replacing. By 2008, much larger lakers were a common sight in Great Lakes harbors. So-called thousand-footers cannot navigate the winding Cuyahoga River at Cleveland, so they use docks that are protected by six miles of breakwater. Lake levels and deferred dredging are worrisome issues on Lake Erie, with many larger ships forced to load at only 70 percent capacity when harbor depths are lower than normal. (CSU, photograph by Byron Filkins.)

The retired bulk freighter *William G. Mather* is a familiar sight to many Clevelanders since she is now a museum ship, docked in Cleveland's Inner Harbor behind the Great Lakes Science Center. The 618-foot-long ship is pictured here during her active life. She was built as the flagship of the Cleveland-Cliffs Iron Company in 1925 and named for the man who served as company president for 50 years. (CSU.)

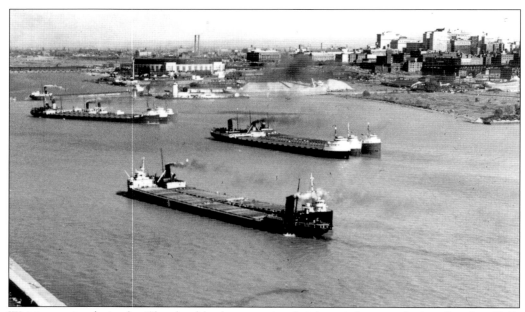

Waiting patiently in the Cleveland harbor are nine freighters, photographed in October 1949. In the 1940s, Cleveland had eight international cargo docks and was reported as the "greatest receiver of iron ore in the world." At that time, 90 percent of the cargo entering and leaving the port was produced or consumed within a 75-mile radius of the city. (CSU, photograph by Robert Runyan.)

Fireboats have been regular actors on the Cuyahoga River and in the lake since 1885. They not only responded to fires aboard ships but also assisted with fires at properties along the river. In the winter, they worked as icebreakers. Cleveland was a pioneer in laying water lines to the river's edge for use by fireboats. (CSU.)

The City of Cleveland built tunnels into Lake Erie as early as 1867 in a search for a clean water supply. As the population expanded, additional tunnels were needed, deeper into the lake. This 1893 proposal by the U.S. Army Corps of Engineers describes a staged plan of building successive cribs to reach a point nearly five miles from what was then the Kirtland Street pumping station on shore. (NARA.)

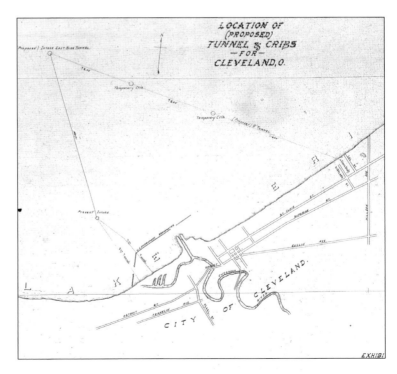

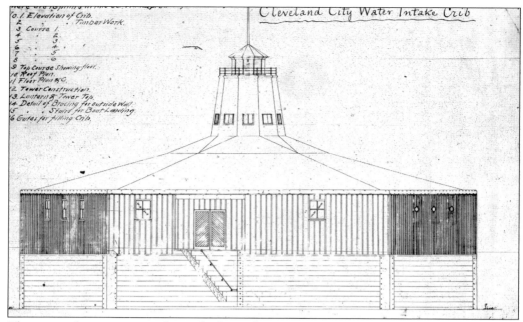

The new crib—a structure that is built on shore, then taken to a site and sunk to the lake floor—covered the intake pipes and mechanical equipment. It was designed as a round structure, 87 feet in diameter, with a lighthouse on top. Construction began in 1896 and was completed in 1904, but sadly, many workers lost their lives in explosions during that time. (NARA.)

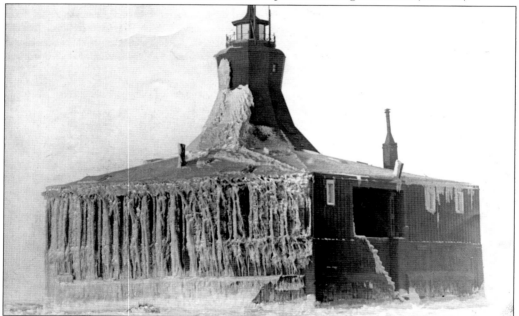

Ice water, anyone? The Cleveland Water Department's intake crib, pictured in January 1912, was completely coated in ice, but the keeper was probably safely on shore by this date since the navigation season had closed. In earlier years, when tunnels were not as deep, frozen intake pipes would sometimes inflict a severe water shortage on the city's residents. (CSU.)

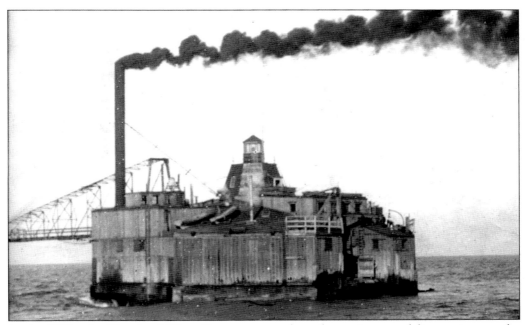

In the 1920s, the Cleveland Water Department undertook a major remodeling project on the five-mile crib, rebuilding its house for the keepers and repairing the 25-foot-high outer wall. The crib is a near neighbor of the lighthouses, located about one and a half miles to the north of the West Pierhead/main entrance light. (CSU.)

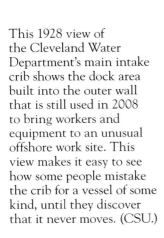

This 1928 view of the Cleveland Water Department's main intake crib shows the dock area built into the outer wall that is still used in 2008 to bring workers and equipment to an unusual offshore work site. This view makes it easy to see how some people mistake the crib for a vessel of some kind, until they discover that it never moves. (CSU.)

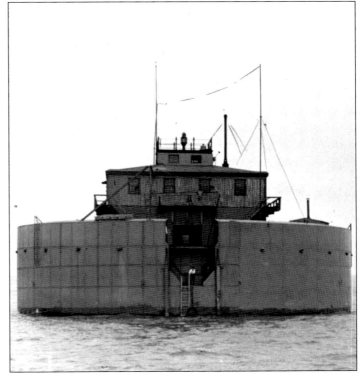

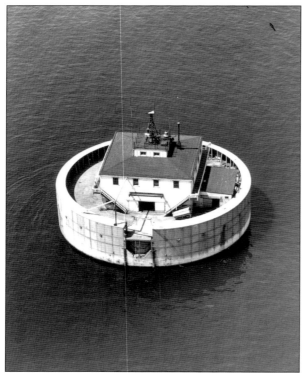

The waterworks crib, photographed in July 1954 by Byron Filkins, looks much the same in 2008 except that the exterior has been painted bright red-orange. It is an active solar-powered private navigational aid and has a foghorn that blows every two seconds when conditions warrant its use. It now has an experimental wind gauge 150 feet above the water surface, part of a feasibility study regarding wind turbines. (CSU.)

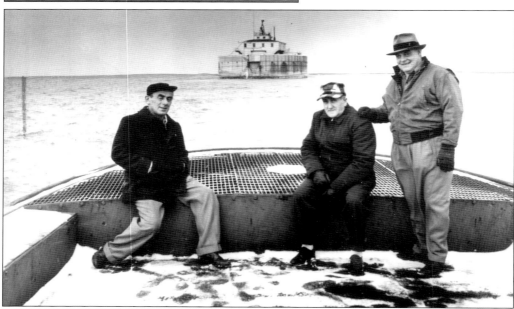

The tug *Virginia* had to break its way through several miles of ice to pick up the Cleveland Water Department employees whose duties at the crib ended on December 22, 1955. A *Cleveland Press* article stated that they worked three- to four-week shifts during navigation season. Today most operations can be managed from shore. Pictured are, from left to right, Edward A. Mueller, Arthur L. Moore, and Glenn P. Hengoed. (CSU.)

Seven

LIGHTHOUSE LOOK-ALIKES

Through the years, the image of a lighthouse has been used in advertising items as an enduring symbol of protection, strength, guidance, and endurance. The mystique of the lighthouse led to the construction of lighthouse look-alikes on at least two lakeshore properties in Greater Cleveland. The same mystique has made many other structures seem like lighthouses to the uninitiated. Small models of America's lighthouses are highly popular collectibles. It is even possible to clothe oneself in lighthouse-printed fashions or decorate one's home with all manner of lighthouse-themed objects.

Cleveland's lighthouses have been offshore for nearly 100 years and are still unknown to many people. The earlier ones on West Ninth Street had been demolished by 1938. However, stories about lighthouses and lighthouse keepers from other shores are part of many people's childhood experience, leading to both fascination and misconception about lighthouses.

Even though there were already two working lighthouses sitting in the Cleveland harbor, the designers of the 1936–1937 Great Lakes Exposition thought a fake lighthouse would be a special feature there. One was built at the Erieside entrance, a noteworthy companion to the visiting ships. Initially it had a strong rotating beam, but that had to be shielded from the lakeside so it would not be confusing to mariners. A second "lighthouse" was present at the exposition near the Streets of the World, but it did not appear on the official Coast Guard list of lights at that time either.

Since Cleveland's main lighthouse sat on a city street on a bluff above the harbor for so many years, it is possible for any large turreted structure to seem like a lighthouse. One such restaurant in Cleveland even uses *lighthouse* in its name but readily notifies customers of the building's real history. When Terminal Tower was completed in 1927, it had a powerful strobe light that was soon replaced by conventional aircraft warning signal lights. It has been easy to imagine that other tall towers around Cleveland, built as clock towers or bell towers, might have been useful navigational devices once.

Careful scrutiny of postcards from Cleveland's 1936–1937 Great Lakes Exposition resulted in the discovery of several lighthouselike structures near the water's edge. One was a red-striped beacon light (at left, above) at the northwest corner of the Streets of the World area. It had the same shape as the beacon that was on Cleveland's West Pier in the early 20th century. In the view below, this striped beacon stands beside a winding walkway near Lake Erie. It is also near a taller clock tower that was part of the wall enclosing this exhibit area. Neither the striped beacon light nor the Erieside entrance lighthouse (see next page) appear as navigational aids on the official list of lights in this period. No other descriptive material was found in exposition materials about the Streets of the World beacon light. (Above, CSU; below, CPL.)

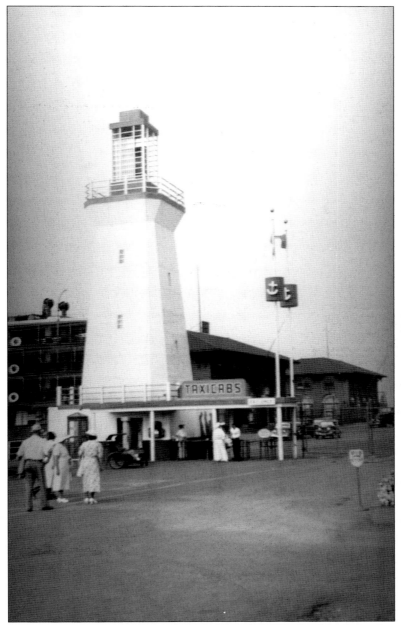

Even though there were two working lighthouses in the Cleveland harbor, planners of the 1936–1937 Great Lakes Exposition decided to add a 30-foot replica lighthouse to the midway. It marked the Erieside entrance to the grounds and served as a taxi stand. Never a true navigational aid, the tower's 36-inch rotating beacon had to be shielded on the lake side to eliminate confusion with other harbor lights. Publicity about the lighting at the fair said that the simulated lighthouse carried "the most powerful rotating beacon in the world today—fourteen million candlepower, seven times that of the famous Rogers-Post beacon in New York." The Rogers-Post beacon had been placed on the George Washington Bridge in New York City in memory of humorist Will Rogers and aviator Wiley Post, who were killed in a 1935 plane crash in Alaska. (CSU.)

A replica lighthouse can be seen at lower left in this postcard view, next to the three-masted barkentine that Rear Adm. Richard E. Byrd used on his second expedition to Antarctica in 1933–1935. The Byrd ship was a highly popular attraction and complemented the Great Lakes Exposition's overall marine theme. Even the poles for general lighting of the walkways were made to resemble ships' masts and davits. (CSU.)

Industrialist John G. Huntington (1832–1895) built this 50-foot tower to disguise a storage tank that provided Lake Erie water for his orchards and farm in Bay Village west of Cleveland. Located on a high bluff, it is often mistaken for a lighthouse. Today it is both a historic landmark and an informal "day mark" for boaters. (Photograph by Don Iannone.)

After living next door to the government lighthouse on Water Street for years, it is not surprising that William J. Gordon would build a lighthouse of his own at his lakeside estate near East Fifty-fifth Street. The Gordon lighthouse is the center point in the photograph above that portrays the sumptuous grounds that Gordon created. He allowed visitors to enjoy the park on Sundays while he was alive, then bequeathed the park to the City of Cleveland upon his death. In the 1896 photograph below, several well-dressed visitors are strolling Gordon Park beach. Although the replica lighthouse never appeared on a Lake Erie navigational chart, it was referenced in some written pieces of the day as a lighthouse. It was torn down in 1901 when a bathhouse was built on the pier. (Above, CSU; below, GLHS.)

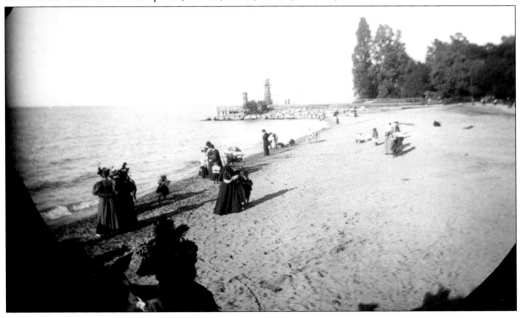

Although it is far from the water's edge—at the corner of West Twenty-fifth Street and Lorain Avenue—the tower for Cleveland's West Side Market greatly resembles brick towers that were common to late-19th-century lighthouses. This 1912 postcard view shows that the tower had both a clock and a light atop it. (Author's collection.)

Cleveland's Terminal Tower has never had as strong a beam as was depicted in this glorified postcard scene. When it was completed in 1927, Terminal Tower had a strobe light that rotated 360 degrees, but this was discontinued a few years later when standard aerial markings were required. The 708-foot-tall landmark still assures many sailors that they are nearing Cleveland and helps identify old harbor photographs. (Author's collection.)

A distinctive conical structure that sits near the Nautica entertainment complex on Winslow Avenue at Sycamore Street, on the west bank of Cleveland's Flats, is strongly reminiscent of the West Pier beacon that marked the harbor in the early 20th century. Designed by architect Robert Corna and constructed in 1987 by Continental Airlines, the tower honors Cleveland's rebirth. (Photograph by Nathan Supinski.)

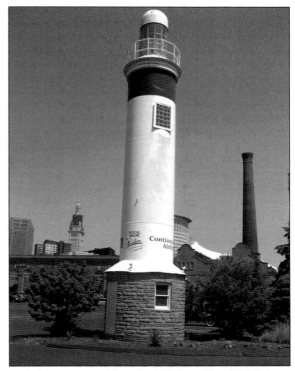

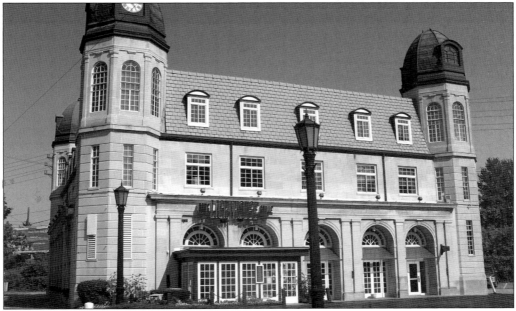

The popular restaurant Don's Lighthouse Grille, at 8905 Lake Avenue in Cleveland, near Edgewater Park, was never a lighthouse despite its name. It was built in the 1920s by Otto Poschke for his barbecue restaurant and had spacious living quarters on the third floor for the Poschke family. It was a Howard Johnson restaurant after Poschke's closed and was opened as Don's Lighthouse Inn in 1971. (Photograph by Nathan Supinski.)

BIBLIOGRAPHY

Annual Report of the Light-House Board of the United States to the Secretary of the Treasury. Washington, D.C.: Government Printing Office, 1852–1903. Continued as Annual Report of the Commissioner of Lighthouses to the Secretary of Commerce and Labor. Washington, D.C.: Government Printing Office, 1903–1910.

Holland, Francis Ross. America's Lighthouses: An Illustrated History. New York: Dover Publishing Company, 1988.

Johnson, Crisfield. History of Cuyahoga County, Part Second. Philadelphia: D. W. Ensign and Company, 1879.

Mansfield, J. B. History of the Great Lakes. Vol. I. Chicago: J. H. Beers Company, 1899.

Meakin, Alexander. Man of Vision: The Story of Levi Johnson and His Role in the Early History of Cleveland. Cleveland: Western Reserve Historical Society, 1993.

O'Brien, T. Michael. Guardians of the Eighth Sea: A History of the U. S. Coast Guard on the Great Lakes. Honolulu: University of the Pacific Press, 2001.

Rose, William Ganson. Cleveland: The Making of a City. 2nd ed. Kent, OH: Kent State University Press, 1990.

Tag, Phyllis. Cleveland Lights. Dayton, OH: Gerald Tag.

Van Tassel, David D., and John J. Grabowski, eds. The Encyclopedia of Cleveland History. 2nd ed. Bloomington: Indiana University Press, 1996.

Wright, Patricia. Great Lakes Lighthouse Encyclopedia. Erie, ON: Boston Mills Press, 2004.

www.boatnerd.com

www.lifesavingservice.org

www.terrypepper.com

www.unc.edu/~rowlett/lighthouse

www.uscg.mil/history

Partial List of Keepers and Captains

It is difficult to construct a complete list of persons who served as keeper for Cleveland's lighthouses as the official records at the National Archives and Records Administration in Washington, D.C., are incomplete for the Cleveland harbor. The lifesaving captains list is courtesy of the U.S. Coast Guard Historian's Office. In addition to these resources, Cleveland city directories were consulted to support this listing. Crozier and Perry became civilian employees of the U.S. Coast Guard when the Coast Guard took over the responsibilities for lighthouses in 1939.

Lighthouse Keepers
Steven Woolverton, 1830–1838
George W. Elwell, 1838–1841
Philo Taylor, 1841–1843
Rich Hussey, 1843–1845
Lewis Dibble, 1845–1849
James Foster, 1849–1853
Paul Chase, 1853–1857
James Farasey, 1857–1861
W. H. Taylor, 1861–1865
George N. Mann/Manor (?), 1865–1867
Ernest Wilhelmy, 1867–1870
C. B. Goulder, 1870–1873
Oliver Perry Perdue, 1872–1881
George Henry Tower, 1881–1885
Frederick T. Hatch, 1885–1887, 1895
Louis Walrose, 1889–1891
Edward Caster (acting), 1891–1895
John T. Johns, 1897–1898
John H. Burns, 1898–1899
Robert E. Gallagher, 1899
Eugene Butler, 1900

Jesse C. Perry, 1916–1917
S. E. Crozier, 1918, 1939–1949
Charles E. Perry, 1940

U.S. Life-Saving Service Captains
Samuel Law, 1876–1878
Charles C. Goodwin, 1878–1893
Lawrence Distel, 1893–1894
Charles E. Motley, 1894–1907
Hans J. Hansen, 1907–1915

ACROSS AMERICA, PEOPLE ARE DISCOVERING SOMETHING WONDERFUL. *THEIR HERITAGE.*

Arcadia Publishing is the leading local history publisher in the United States. With more than 3,000 titles in print and hundreds of new titles released every year, Arcadia has extensive specialized experience chronicling the history of communities and celebrating America's hidden stories, bringing to life the people, places, and events from the past. To discover the history of other communities across the nation, please visit:

www.arcadiapublishing.com

Customized search tools allow you to find regional history books about the town where you grew up, the cities where your friends and family live, the town where your parents met, or even that retirement spot you've been dreaming about.